Getting

Unlimited

Impact

with

Limited

Color

by
Mike Zender

Getting
unlimited
impact
with
limited
color
by
Mike Zender

Getting Unlimited Impact With Limited Color. Copyright © 1994 by Mike Zender. Printed and bound in Hong Kong. All rights reserved. No part of this book may be reproduced in any form or by any electronic or mechanical means including information storage and retrieval systems without permission in writing from the publisher, except by a reviewer, who may quote brief passages in a review. Published by North Light Books, an imprint of F&W Publications, Inc., 1507 Dana Avenue, Cincinnati, Ohio 45207. 1-800-289-0963. First edition.

This hardcover edition of Getting Unlimited Impact With Limited Color features a "self-jacket" that eliminates the need for a separate dust jacket. It provides sturdy protection for your book while it saves paper, trees and energy.

97 96 95 94 93 5 4 3 2 1

Library of Congress Cataloging in Publication Data

Zender, Mike.
 Getting unlimited impact with limited color / by Mike Zender
 p. cm.
 Includes indexes.

 ISBN 0-89134-568-X
 1. Color-printing. I. Title
Z258.Z46 1994 94-20000
686.2'3042–dc20 CIP

Edited by Dawn Korth, editorial concept by Mary Cropper
Interior design by Mike Zender
Cover design and illustration by Mike Zender

The following page constitutes an extension of this copyright page.

Credits

Acknowledgements

I wish to thank:

Dawn Korth

for wise editorial advice and encouragement,

Mary Cropper

for wise editorial advice and skillful production and project facilitation,

Kristy Zender

still the only little girl in my heart, for efficient organization and project management,

Dave Blumberg, EDGE Graphics

for costing assistance

Designers

who generously submitted their work,

My Family

for patience with me,

Zender + Associates, Inc.,

for facility and emotional support

My Lord,

for gifts to share.

Contents

Introduction

Color has impact. Our lives are enriched or impoverished by color or its lack. Color expresses our deepest feelings. We see red. Someone short on courage is yellow. We are green with envy. Color is important, and so is money. We pray for our daily bread. We save and invest. We budget. This book is about color and how to make the most of it in offset printing.

Why does color have to cost anything? In printing, color costs because of the machinery and technology involved. Printing presses transfer thin films of ink onto paper by means of metal plates and rollers. On press, each color requires a separate roller and plate set to form a unit. Presses are described by the number of units they contain; hence, a six-color press has six units. Each unit can print any ink color. However, the number of units on a given press is not easily changed, so that printing a six-color project on a four-unit press would require sending each paper sheet through twice — once to print four colors and again to print the final two. Each pass through the press increases cost.

Offset presses are large, complex machines; the larger and more complex they are, the greater the number of color units they contain, the more they cost to build, maintain and use. Multi-unit presses also require more operators, which means it costs us, the client, more to buy press time for our job.

In addition to press time, the cost of preparing film for the press is a substantial part of a printing budget. A separate film and plate set is required for each press unit. There are no significant savings in preparing several film and plate sets, so preparing plates for two units or two colors is generally twice as expensive as for one. Since each color adds preparation cost, most techniques for stretching your color dollar involve creating the appearance of printing more ink colors than you paid for.

Color is an ambiguous topic. We think we know something about it, but as soon as we try to get specific, it becomes as elusive as a rainbow. What color is purple? Is purple more red than blue, or more blue than red? Color is a loose term used to describe many things. I define color as the visual aspect of things which is caused by their interaction with, or emission of, light. Color can be described by three parameters: value, hue and intensity. Value describes color's lightness or darkness; hue describes specific wavelengths of the spectrum of visible light from red to violet; and intensity describes the brightness of a color, from muted to bright. Each of these variables is manipulated by the designer to communicate and create beauty.

Color exists apart from sight, but if you can't see, color is meaningless. When light strikes the retina of the eye, a pigment is momentarily bleached generating a brief electronic impulse to the brain. This chemical mechanism can become saturated resulting in the illusion of shapes and colors which do not exist in reality. This makes the perception of color a personal and inexact activity. Lighting, experience, environment and even diet can affect our perception of color. Good color stewardship requires some understanding of the relationship between perception and color. Josef Albers's classic work, *Interaction of Color* (Yale University Press), is an enjoyable and excellent primer on how color works.

Each section of this book examines a technique to maximize color's impact and minimize its cost. In each case there is a discussion of the technique's relationship to printing technology and to color perception. A cost comparison is given. Demonstrations illustrate key points while examples show the technique applied to real projects. The techniques covered are not exhaustive, but they are intentionally presented in a way that will encourage exploration and the development of new techniques.

The basic concept driving this book is steward-ship. The search for maximum impact at mini-mum cost stems from the basic desire to be good stewards: to do our best with the gifts of time, tal-ent and treasure that have been entrusted to us. We are free to waste, but to our own detriment. Resources are not inexhaustible. There are only so many trees. Even the wealthiest people have only so much money. We have only so many days to live and work.

I am constantly amazed and humbled that some-one will pay me to work. Work is a gift, not a bur-den. My prayer is that this work will help you do yours better.

About the Author

Mike Zender is a third-generation designer/typesetter, following in the steps of his father and grandfather. Mike has been the beneficiary of an excellent educa-tion, first attending the University of Cincinnati during the formative years of what has become an excellent program, then studying at Yale University under many of this century's best designers. He found-ed his design office one month after finish-ing graduate school and began part-time teaching one year later. Mike's work, and that of the associates in his firm, has been published regularly since 1980.

Mike lives in southwestern Ohio with his high school sweetheart and three amazing children. Designing, writing and teaching are outward expressions of his introspective and thoughtful personality.

Glossary

Additive color -
method of mixing colors by projecting light in the additive primary colors: red, green and blue.

Additive primaries -
hues not derived from the mixture of any other; the essential hues of projected light: red, green and blue.

Binding -
combining folded signatures into multipage documents using glue, thread, or metal wires.

Bitmap -
a grid of individual dots or pixels that make up a graphic display.

Blended fountain -
printing with several ink colors in one ink fountain.

CMYK -
cyan, magenta, yellow, and key (black); the four hues used to describe and separate images for color printing.

Color -
visual aspect of things caused by their interaction with, or emission of, light.

Complementary colors/Chromatic opposites -
hue pairs (red/green, blue/orange, yellow/violet) which combine to neutralize each other, forming gray or black.

Continuous tone -
shades of gray in a photographic image.

Die-cutting -
fine cuts made in a flat sheet of paper or plastic as a result of pressing against sharp metal dies.

DPI -
Dots Per Inch, measure of the resolution/addressability of a raster device such as a laser printer.

Duotone -
an image with an expanded tonal range made by combining two separate halftones of the same image, printed in two different ink colors.

Duplex paper -
paper that has different finishes or colors on opposite sides; usually formed by adhering two sheets together.

Ghosting -
printing fault resulting in an unwanted lighter image appearing in an area of solid ink coverage.

Halftone -
an image created by converting a continuous-tone picture to printable image by turning it into a pattern of tiny dots of various sizes; formed electronically, by scanning, or by photographing it through a grid-like screen.

Hues -
the parameter of a color that is perceived and described by the spectrum of visible light, ranging from red to yellow, to green, to blue, to violet.

Ink -
colored, oily paste consisting of pigments, dyes, vehicle and additives. Used in offset printing.

Ink fountain -
ink source of a printing press.

Intensity -
relative brightness of a color, from muted to bright.

Match color -
premixed ink colors. Several systems exist to specify colors.

Misregister -
improper alignment of printing plates resulting in improper alignment of colors.

Moiré -
unwanted coarse texture caused by superimposition of regular patterns, such as halftone dots.

Mono/Monochromatic -
black-and-white, or the values of one color.

Offset lithography -
printing based on the principle that oil and water do not mix. The image is transferred (offset) from the plate to a blanket and then to the final substrate (paper); also a printing fault when ink transfers from one printed sheet to another.

Paper -
a material made of cellulose pulp that has been processed into thin sheets or rolls.

Primary colors/hues -
hues not derived from the mixture of any other; the essential hues: cyan, magenta and yellow (blue, red, yellow).

Reflected color -
color caused by reflecting light from an object. The object or its coating absorbs several wavelengths of light energy and reflects the remaining wavelengths, seen as color.

Register -
proper alignment of printing plates resulting in correct alignment of colors.

Reverse areas -
small light areas set against larger black or dark color background.

RGB -
red, green, blue — the primary hues of transmitted light. Used on computer monitors and television screens.

RIP -
Raster Image Processor - a device that converts a vector file into a bitmap.

Saddle stitch -
binding method using wire staples along the fold of a document.

Scanning -
using an electronic device to measure and record color densities of an image as a computer file. Scanned images are converted into halftones for printing.

Screen angles -
adjusting the orientation of halftone screens to minimize the formation of moiré.

Screen tints -
values of a color, specified as percentages of the original hue, created by applying different densities of halftone screen. Screen tints are always lighter than the original hue.

Secondaries -
hues that result from mixing the primaries;

red + yellow = orange

blue + yellow = green

red + blue = purple.

Signatures -
many pages of a book printed on a single sheet of paper from the same plate and arranged so they can be folded and trimmed to make a section, usually of 16 pages.

Stochastic or Frequency Modulated screen -
random pixel arrangement used to reproduce high-resolution images.

Subtractive color -
method of mixing colors by absorbing some wavelengths of light in a pigment coating/ink while reflecting others.

Subtractive primaries -
hues not derived from the mixture of any other; the essential hues of reflected light: cyan, magenta and yellow/blue, red, yellow.

Tonal densitiy -
the degree of optical opacity of a medium or material (such as a photograph), as measured by a densitometer.

Trapping -
small overlap along the edge of adjoining colors causing slight misregistration in printing.

Tritone -
an image with an expanded tonal range made by combining three separate halftones of the same image, printed in three different ink colors.

Unit -
arbitrary width module, usually based on a fraction of an EM (a square encompassing the capital letter M), used to control proportions and spacing in electronic type fonts.

Value -
parameter of a color describing the lightness or darkness of a hue, changed by adding black or the complement to a particular hue.

Vector -
a point specifying a magnitude and a direction for a line. Used to create electronic fonts and images in layout software.

Wash-up -
cleaning of the press in preparation for a printing run.

1

Single-Color Techniques

Limitations are constraints that focus our creative efforts. They cause our imagination to soar. A lot can happen with just one color. This section explains various techniques which will maximize the impact of one color. Each technique is itself a variable and has several variables associated with it. This is illustrated in the matrix on the next page. Like any grid or structure, the matrix of these variables encourages creative exploration rather than limiting it. I use a matrix like a menu, to dish up design ideas and enrich even the simplest assignment. As a beginning point, I encourage you to explore the immense possibilities within just one technique before combining techniques. This will help reduce confusion and expand your understanding a step at a time.

Not all one-color printing jobs cost the same; the costs of the techniques in this chapter range from 1.1 Reverse Areas, the least expensive, to 1.9 Other, Embossing, the most expensive. Although most single-color print jobs will cost as much as 80% less than four-color printing, check with your printer to establish your actual cost and savings.

This matrix is a graph of the techniques covered in this chapter. Each technique's variables are shown as a continuum bounded by opposites. Notice that techniques that involve two steps, 1.6 Different Sides Print a Different Color, for example, have twice as many variable options.

	Size Large Small	Quantity Few Many	Value Dark Light	Hue Red. Or. Yel. Gr. Bl. Violet	Intensity Muted Bright
Reverse					
Halftone Tint					
Blended Fountain					
Color Paper					
Change Ink					
Change Backup					
PrePrint Imprint					
Special Inks					
Other					

Variables

Size	Large - Small
Quantity	Few - Many
Value	Dark - Light
Hue	R O Y G B V
Intensity	Dull - Bright

Reverse Areas

Cover large areas for maximum impact.

Ever notice how small the court looks in a professional basketball game? That is, until a regular-size human walks out on the court to define the players as giants! An arena full of giants makes the court look smaller. The mirage created by comparison and contrast is also a key in getting the most for each color dollar.

Large solid areas of ink contrasting with small spots of unprinted paper make reverse areas. Large reverse areas can trick the mind into seeing the paper color not simply as background but as a separate printed color, sort of a two-for-the-price-of-one deal. In addition, carefully manipulating the tension between large and small quantities of dark ink can actually form the illusion of new darker or lighter paper color values. This use of contrast for dramatic effect is more than a nice color principle; it's also a basic aesthetic principle important to any effective composition. Employing key aesthetic principles of opposites and contrast makes not only good economic sense but good visual sense as well. It will help you squeeze the most from your budget.

The good news is that solid and reverse areas have virtually no effect on printing cost. Only on very large press runs with hundreds of thousands of impressions of large solid and reverse areas, would the additional cost for larger quantities of ink become a factor. Printing large solids with reverses can be tricky however, and printing difficulties often increase cost. If art is prepared in positive form, be sure to indicate to the printer what areas are to be reversed.

Comparison and contrast are essential features of our visual perception. A single large dark area will make very small light areas seem to glow with brightness. It is as though the dark surrounding area were sucking darkness from the light area that it encloses. There are sound physiological reasons for this, with chemical and neurological stimulation, repetition and fatigue all playing a part. A typical test demonstrating this would be to stare at a small white square in a black field for several seconds, then quickly avert your eyes to a blank white area. A faint dark square, the exact size of the white one, will appear in the blank white area. This afterimage demonstrates the effect size and quantity contrast has on our visual perception. It is a good idea to contrast a very large dark color area with a tiny light spot. This uses perceptual process to add visual power to a limp color palette.

PURPLE

Demo 1.1.1

Printing purple on white paper makes the small reverse white squares appear brighter white than the larger reverse area below them. The fine grid lines are so small that rather than appearing white, they begin to blur with the purple to create the illusion of a light purple area.

In addition to afterimage effects, our eyes also accept the largest area of a visual field as background or ground, and smaller visual elements scattered upon it as objects or figures. Reverse areas can take advantage of this figure-ground convention to make the paper color appear as figure and the printed color appear as ground. A medium-value ink, like chocolate brown, on a medium-to light-value paper, like cream or tan, is especially effective at creating this fantasy. All at the cost of a little knowledge and creative thinking!

It is the essence of good design to use visual effects to reinforce content. I might contrast a table of contents reversed out of black with a mostly white cover and title page, or reverse a sidebar or a masthead for emphasis. This uses a money-saving technique to add clarity to content and to distinguish between types of information.

I enjoy the effect that light ink colors have on light colored paper as well. It makes it hard to tell which color is printed and which is paper, making for a playful and diverse piece.

T A N

Demo 1.1.2

Printing a large area of medium tan ink creates the illusion of tan colored paper, while the light gray paper takes on the appearance of a second ink color.

Demo 1.1.3

After using the tan ink to simulate paper color, dramatically reducing the quantity of tan ink coverage on a subsequent page enhances the effect while adding diversity.

Like any powerful tool, reverse areas have their dangers.

Small type or fine lines reversed out of large solid ink coverage will tend to fill in on press. The viscosity of the ink causes it to overcome the repellent quality of the water in tiny areas and they fill in. Avoid this pitfall by using bold, sans serif type in reversed areas. Avoid reversing fonts with thin serifs, like Bodoni, and be careful when reversing very small point sizes in any font, even sans serifs like Helvetica.

Ghosting is an unwanted lightening in areas of solid ink coverage. It happens on press because reverse areas don't draw any ink from the rollers. Ink is dramatically depleted in the area of solid coverage immediately adjacent to a reverse area where no ink is used causing uneven ink distribution on the rollers. This makes a change in ink film density on the paper. The result is a light, ghostly image in what should be solid printed areas.

You can avoid ghosting by running the printed area at an angle to the edge of the paper, rather than parallel, as is usually the case. This spreads out the difference in density. Show your design to your printer to discuss specific remedies for your particular project.

1.1.1

Joe Bottoni

Soldner poster,
23" x 35".
The small torn reverse
areas form bright
shapes compared to
larger white rectangle.

WGBH Boston
125 Western Avenue
Boston
Massachusetts
02134

Season Two

Long Ago & Far Away

1.1.2

Douglass Scott,
WGBH

Long Ago & Far Away
envelope, 9" x 12".
Reverse dark blue ink
printed on white enve-
lope is appropriate to
the subject matter.
Small, Season Two type
looks slightly brighter
white, compensating for
smaller size with
increased brightness.

1.2 Halftone Tints

Use halftone tints to make many values from one ink color.

I remember being fascinated by magicians with their amazing deceptions and the optical illusions illustrated in elementary school science books. It seems we can't believe our eyes. Believe it or not, designers depend constantly on an optical illusion called the halftone and work their own design magic with halftones to expand a color budget.

Halftone printing technology is a process based on optical phenomenon. It uses fields of dots so tiny that at normal viewing distance, and without the aid of magnification, solid black dots disappear and form a field of light gray. Our eyes blend the tiny samples of ink color with the color of the paper to form a new color value that doesn't really exist.

This high magic is available free at any printer. Well, almost free! At minimal cost, the halftone dot has amazing power to add impact to a color budget. Understanding a few terms is necessary to get started.

Halftones are specified as percentages of solid color. A 50% halftone is a checkerboard of alternating ink and non-ink dots, each the same size. The result looks half as dark, 50%, as the solid color. A 20% halftone has a pattern of very small dots of ink surrounded by large nonprinting areas: a 90% halftone is almost solid ink containing a pattern of tiny nonprinting dots. Printer's halftone screen tints usually come in 5 or 10% increments, typically 5%, 10%, 20%. Computers are capable of generating halftones in 1% increments.

In addition to specifying tint percentage, halftone screen frequency must be specified as well. It is described by the number of dots or lines per inch. A 150 dot-per-inch (dpi) halftone screen has 150 dots per lineal inch. For the average person, individual dots become visible at screen frequencies of 90 to 120 dpi and less, causing the illusion of the halftone to break down.

Halftones may be made of round dots, elliptical dots, straight lines and irregular shapes. It is even possible for a computer to make halftone dots the shape of tiny smiley faces! While some dots make smoother halftones with more perfect illusions of color than others, they all serve the same end, creating the illusion of a nonexistent color.

I use a printed tint selection guide, like one readily available from Pantone or printers, to help choose a halftone percentage for my ink color. I refer to a guide even when specifying screen tints on computer. As you know, what you see on the monitor is never what you get for output.

MAGENTA

Demo 1.2.1

Printing a single ink color (magenta), using various halftone types (round dot and line), adds variety to screen tints. Changing screen frequency (10, 30 and 120 round dots per inch) adds even greater diversity.

Cost Comparison: 20% more than benchmark, page 13.

Halftones can only make an illusion of color that is lighter, a tint, of the original solid color. That's why they're called screen tints. The result is a color palette that is monochromatic, one hue with many possible tints. The selected ink color is the darkest with each screen tint being a lighter variation of the same hue.

Selecting an ink color that is very light in value limits the tonal range available through screen tints and restricts color impact. The difference between a very light color and its 50% tint will be much less than the difference between a very dark color and its 50% tint. Using a light color robs you of a number of possible lighter values and limits the potential diversity of effects. You should select an ink color that is very dark if you want the widest possible diversity of values.

PURPLE

I frequently choose a dark ink and make a blend or smooth gradation of it, from 100% to 0%, creating the maximum possible number of values. I discovered the beauty of gradations using an airbrush long ago and still enjoy their richness and subtlety.

Like any magic, the halftone process has some potentially lethal combinations! Using a very high-frequency halftone screen, 150 dpi or higher, with a very dark screen value, 90% or higher, on uncoated paper can set up a disaster. The tiny paper colored dots tend to fill in, or "plug," on press turning the halftone screen into dark mush. Similarly, the discrete ink dots of fine light tints, 40% or lighter, tend to expand, or "spread," making a darker than desired area.

You shouldn't bother specifying a 1% halftone, or a 99% for that matter. They probably can't be printed. On one hand the ink dots are too small, and on the other the nonprinting dots are too small. A 3 to 5% dot is usually considered the minimum, and 95% the maximum, printable halftone.

Sizes of tints, small - large

Quantity of tints, few - many

Value of tints, dark - light

Frequency of halftone screen - dpi

Type of halftone screen, dot - line

Demo 1.2.2

Printing a dark color (purple) on white paper creates a wide variety of distinctly lighter values. The blend further maximizes the number of values.

LT GREEN

Demo 1.2.3

Printing a light ink
color (light green) on
white paper limits the
number of lighter
screen tints/values.
Here 50% is only slight-
ly different than 75%
below it. Text can be
so light that legibility
is reduced.

Program

Outstanding Speakers
Presentations by experts: critics, curators, art historians, biographical researchers such as April Kingsley, Virginia Watson-Jones, Charlotte Streifer Rubinstein, Ann Sutherland Harris, Eleanor Munro, Annie Shaver-Crandell, as well as many established and emerging sculptors.

Topics
A small sample: figurative sculpture, narrative work, spiritual concerns, personal and historical references in iconography, mergers and fusions - sculpture as painting and sculpture as architecture. Site and scale-related topics such as indoor/outdoor sculpture, permanent/temporary, site specific work. Idea sources such as rituals, myths, ancient culture, art history, intellectual history, mysticism. Media-alike sessions on sculpture in wood, ceramics, metals, fiber and more.

Practical Sessions
Information on: health hazards; sources of commissions, exhibitions; legal-financial issues; handling heavy works, shipping sculpture; photographing sculpture; slide registry services and more.

Networking
Time and space for networking by occupational role, region and interest.

Continuous Slide Presentations

Honorees: Distinguished Sculptors
Louise Bourgeois
Elizabeth Catlett
Clyde Connell
Dorothy Dehner
Claire Falkenstein
Sue Fuller
Louise Nevelson
Claire Zeisler

Exhibitions

Seventeen special exhibitions of sculpture by American women. Exhibition of inflated and other air-supported sculpture.

Concurrent Art Critics' Conference
Art critics' conference sponsored by *Dialogue, An Art Journal.* For the Fifth Annual Critics' Conference, April Kingsley, Craig Owens and Stephen Westfall will join artists Vito Acconci and Adrian Piper, as well as museum directors, to address "the impact of criticism." For more information, write *Dialogue*, PO 2572, Columbus, Ohio 43216.

National Advisory Committee

Lita Albuquerque Sculptor. Los Angeles
Dennis Barrie Director, Contemporary Arts Center. Cincinnati
Sallie Bingham President, The Kentucky Foundation for Women, Inc., Louisville
Beverly Buchanan Sculptor. Atlanta
Deborah Butterfield Sculptor. Bozeman, MT
Donna Dennis Sculptor. New York City
Barbaralee Diamonstein-Spielvogel Author, Television Interviewer/Producer. New York City
Rowena C. Elkin Sculptor. Dallas
Lin Emery Sculptor. New Orleans
Christine Federighi Sculptor. Miami
Bill FitzGibbons Director of Sculpture, Visual Arts Center of Alaska, Anchorage

Howard N. Fox Curator of Contemporary Art, Los Angeles County Museum of Art
David M. Furchgott Director, International Sculpture Center, Washington, D.C.
Wilhelmina C. Holladay President, The National Museum of Women in the Arts. Washington, D.C.
Nancy Holt Sculptor. New York City
Mary Jane Jacob Chief Curator, Museum of Contemporary Art. Chicago
Mrs. Fred Lazarus III Patron, Board member, American Council for the Arts. Cincinnati
Samella S. Lewis Art historian, Founder: The African American Museum of Art. Los Angeles
Lucy Lippard Art critic, Author *Overlay.* New York City
Charles Miller Managing Editor, *Artforum.* New York City
Mary Miss Sculptor. New York City
Marianna Pineda Sculptor. Boston
Craig Owens Senior Editor, *Art in America.* New York City
Charlotte Streifer Rubinstein Art historian, Author *American Women Artists.* Laguna Beach, CA
Diane Samuels Sculptor. Pittsburgh
Annie Shaver-Crandell President, Women's Caucus for Art. New York City
Lowery S. Sims Associate Curator, 20th Century Art. The Metropolitan Museum of Art. New York City
Ann Sutherland Harris Professor of Art History, University of Pittsburgh
Eloise Spaeth Honorary Chair, Archives of American Art. New York City
Hannah Stewart Sculptor. Houston
Mary Stoppert Sculptor. Chicago
Athena Tacha Sculptor. Oberlin, OH
Patti Warashina Sculptor. Seattle
Margaret Wharton Sculptor. Chicago

National Sculpture Conference: Works by Women May 7 thru 10 1987 Cincinnati, Ohio

1.2.1

Joe Bottoni

Women Sculpture brochure, inside spread, 11" x 17". Many screen tints are used, some round dot and some a hand-drawn texture.

1.2.2 A & B

KODE Associates
Inc.

LinoGraphics prepress
capabilities brochure,
5.5" x 8.5".
Various screen tints on
translucent paper maxi-
mize the number of gray
values. The great num-
ber of tints, textures
and screen types is not
only handsome but
appropriate for the
topic.

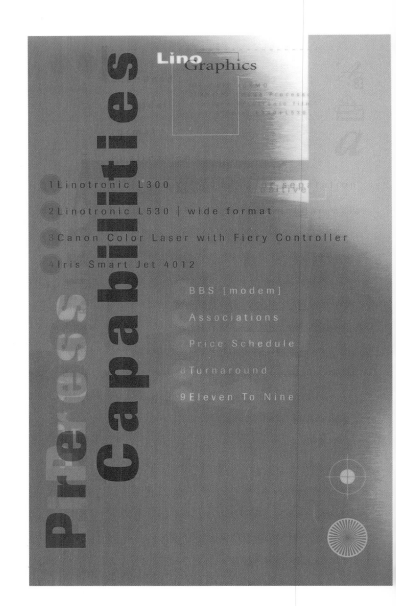

LinoGraphics

Prepress capabilities

1 Linotronic L300
2 Linotronic L530 | wide format
3 Canon Color Laser with Fiery Controller
4 Iris Smart Jet 4012

BBS [modem]
Associations
Price Schedule
8 Turnaround
9 Eleven To Nine

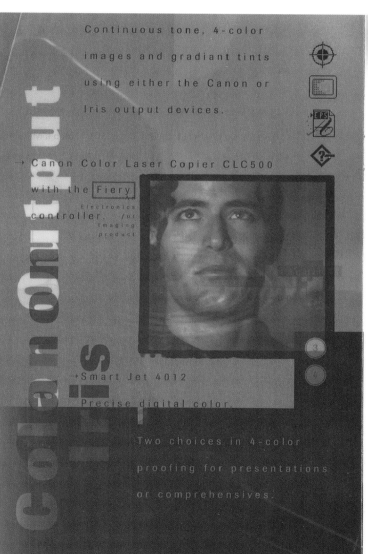

Continuous tone, 4-color
images and gradient tints
using either the Canon or
Iris output devices.

→Canon Color Laser Copier CLC500
with the Fiery
controller.

→Smart Jet 4012
Precise digital color.

Two choices in 4-color
proofing for presentations
or comprehensives.

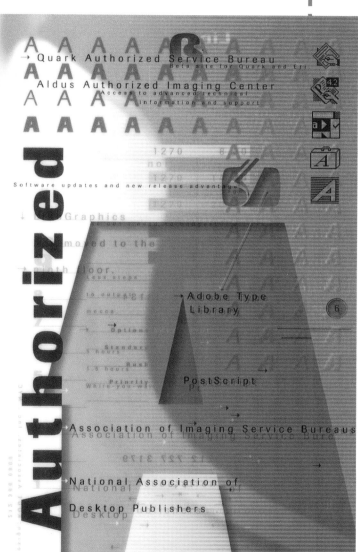

Quark Authorized Service Bureau
Beta site for Quark and Eri

Aldus Authorized Imaging Center
Access to advanced technical
information and support

Software updates and new release advantage

→Adobe Type
Library

PostScript

Association of Imaging Service Bureaus

National Association of
Desktop Publishers

1.3 Blended Fountain

Print with several ink colors in one ink fountain.

Rainbows are God's ultimate color variety. Blend sunshine and water in the sky and the spectacular happens. The unrivaled beauty that is free in nature is almost free in the printing world as well! Amazing but true!

A single beam of sunlight contains all visible colors blended together. Printing technology also has the capacity to blend different colors of ink together on a single-color press, a technique typically called a blended fountain. It can be quite a bargain.

Offset presses apply ink drawn from a broad horizontal fountain, the source of the ink that is transferred to the paper. Generally presses are set up with a separate fountain for each color, and each color fountain is part of an individual color unit, so that a six-color job would use a press with six units. Presses with multiple units are more complex to build, more difficult to control, more work to clean and to operate, and more costly. But it is possible to blend several colors of ink from a single fountain, hence the blended fountain. This creates an ink made not of one color but of a rainbow of colors for the cost of one.

It is difficult to predict the color mixtures formed on press in a blended fountain. The proposed combination may be tested by simply mixing together colors of paint that match the proposed ink colors or by creating a color blend on a computer screen. The blended fountain is specified by noting on the mock-up or final art where each color is to stop.

To print a blended fountain, the entire job is prepared as a typical one-color project. On press, the pressman simply builds little dams in the tray where normally one ink color is laid and puts a different ink into each subdivision. As the ink flows from the fountain to the rollers on the press, the colors blend, gradually forming a seamless ink film of many colors. But there are dangers.

Remember finger painting as a child? Remember adding color to slimy color to create a homogenized gray pudding, and wondering where all the beautiful color went? When it comes to blended fountain color, more is not always better. Over time the colors may blend too much, contaminate each other and make color mud.

Since making a blended fountain is the making of new colors by mixing, knowledge of color mixing is critical to successfully specifying a blended fountain. Newton discovered long ago that white light contains all the colors of the spectrum. He identified the original blended fountain, a fountain of sunlight. Just three primary colors of reflected light (cyan, magenta and yellow) blend to create virtually every other color. These primaries each blend to form

R E D

G R E E N

Demo 1.3.1

Printing a blended fountain of complementary inks (red and green) creates shades of gray-brown as the red and green inks mix.

Cost Comparison: 10% more than benchmark, page 13.

the reflected secondaries: orange, green and violet. Together the primaries and secondaries form opposite color pairs, chromatic opposites. Whereas blending each primary pair forms a new and different secondary color, blending chromatic opposites always produces gray. For example, combining chromatic opposites such as red and green in a blend forms a fountain with a blend of three colors: red, green and gray; putting primaries or primaries and secondaries such as green and blue together will form a fountain with a blend of three colors: blue, green and blue-green.

I prefer blended fountains that mix chromatic opposites and unusual combinations to generate unexpected results. Selecting neighboring colors of the spectrum forms the smoothest blends, but also the most predictable ones. Select hues of varying values and intensities and make surprising results.

I suggest using a blended fountain whenever the content cries out for color diversity. A floral woodcut would be an intriguing subject for a colorful treatment, much more appropriate than simply defaulting to the typical black ink, making black flowers. The opposite could also work. Subject matter like coal, which is typically black, could be made ironic, even humorous, by printing it in a rainbow of color.

LT BLUE

BLUE

GREEN

Sizes of blends, small - large

Quantity of blend, few - many

Hues of inks, primary - neighbor - opposite

Values of inks, dark - light

Intensity of inks, intense - subdued

Size of each hue within blend, small - large

Demo 1.3.2

Printing a blended fountain of near neighbor colored inks (light blue, blue and green) creates shades of blue-green as the light blue, blue and green inks mix.

Blending water and dirt together makes mud. Blending inks on a single ink fountain can have unwanted effects on press, too. As the press continues to run, the ink colors blend successively and the distinction between colors dissolves into one unified color, usually a muddy one. Frequent wash-ups to overcome this problem will add cost to your job.

LT BLUE

BLUE

GREEN

Demo 1.3.3

Allowing a blended fountain to blend too much will make a uniform, muddy color.

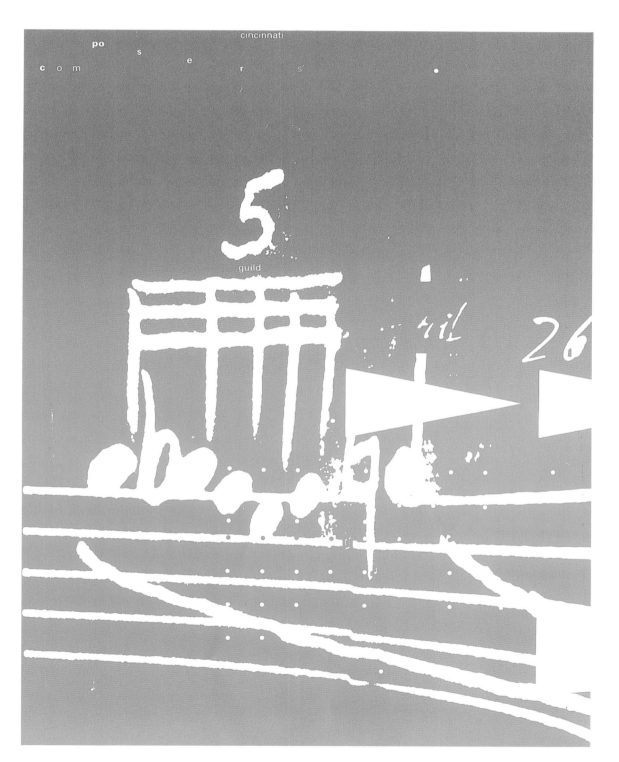

1.3.1

Mike Zender,
Zender +
Associates, Inc.

Composers' Guild
flyer/poster, 8.5" x 11".
Blended fountain of
gray to red to green
forms red-gray between
the red and gray, and
gray-brown between
the red and green. The
intent was to make the
gray formed from the
red-to-green blend the
same color as the gray
at the top. The large
reverse area interrupt-
ed by linear music nota-
tion emphasizes the
smoothness of
the blend.

.3

1.3.2

Joe Bottoni

Bottoni and Hsiung
Christmas Card,
20″ x 20″.
Blended fountain of red
to green forms a gray-
brown in between. A
blend in small textural
icons is more subtle
than a blend in a large
reverse area, apt for the
season, a time of holi-
day celebration.

2021 Getting Unlimited Impact with Limited Color

1.3.3

Joe Bottoni

Bottoni and Hsiung
Christmas Card,
20" x 20".
Blended fountain of red
to blue forms a purple
in between.

Colored Paper

Specify different paper colors on different pages or projects.

How often do I admire the foundation of my house? Plantings, flowers, window boxes, even windows maybe, but the foundation, not often. The foundation of most graphic design is paper. A little creative attention to color selection of the foundation of our projects can produce major impact and big savings.

It is no surprise that paper comes in a variety of colors. The fact that colored papers seldom cost more than white may surprise you. It may surprise you even more to think of paper as a way to add colors to a project. When your project calls for the printing of several individual pieces, like letterhead, envelope and business card, or even many pages bound together, like a book or brochure, then selecting a variety of colored papers will add impact but not cost.

Here's how. Since paper must be purchased for most projects anyway and the cost of many colors of paper is the same as the cost for one, then from a color quantity standpoint, the price is right. How much latitude exists in mixing paper colors on a given project depends on the method of binding used. Saddle stitch, where pages are stapled together along the spine, is the most limited. Perfect binding, where pages are glued together along the spine, has more creative room to mix and match color stocks, and a loose collection of pages, such as inserts in a pocket folder, has ultimate flexibility. Any situation that allows combination of various paper colors on the same project offers great potential for adding color impact.

Most uncoated paper grades come in a variety of colors. Some grades have carefully coordinated color systems with a balanced range of hues and values, Gilbert ESSE being notable in this regard. This makes harmonious mixing of various colors relatively easy. Other grades that are less coordinated are still extremely useful. Some uncoated paper lines have duplex papers, with two thin sheets of different colors glued together. The color benefits are obvious but the cost may be high. Coated papers, on the other hand, seldom have much color variety. ZANDERS' Ikonofix and Chromolux are notable exceptions. Regardless of paper type chosen, handsome color combinations can be created. Paper swatch books showing the full range of color options are available from paper manufacturers and merchants. Merchants not only show printed samples demonstrating color on various papers, but also offer advice in paper specification.

The color paper you choose affects ink color. Nearly all inks are transparent, allowing the paper color to show through and affecting the apparent color of the ink. While this can be compensated

BLUE

Demo 1.4.1

Printing a single ink color (blue) on three primary paper colors (pink, green and yellow) changes the color of the blue ink on each paper.

for in the ink formulation, the ink/paper color interaction can also be used for creative effect. Blue ink on yellow paper will turn green, for example. In this way one ink color applied to a variety of paper colors will look slightly to dramatically different on each color stock. Books are available to help predict what a given ink color will look like printed on colored paper, but books have a limited number of color choices, meaning your exact color probably won't be illustrated. But they help.

I use opaque inks if the color needs to look consistent on different colored papers. Metallics are perhaps the most opaque of all inks. While they lose much of their metallic sheen on uncoated paper, I enjoy the subtle luster they have compared to nonmetallic inks on uncoated stock, and their great opacity virtually guarantees color consistency on any colored paper.

I avoid defaulting to black as my ink color, especially when the project is likely to include typing, copying or imprinting. These processes rely on black toners or inks that can become a second ink color, resulting in a three-color finished project when my ink, the toner and the color paper combine.

I see duplex paper as an opportunity to use a creative fold or a die-cut to expose both the back and front, and the different colors of the duplex, at the same time. This makes both colors visible at once for comparison and contrast. Juxtaposition enhances the difference of a single ink color on different color paper. I like to use direct contrast to magnify subtle color shifts that would likely go unnoticed otherwise. It's a way to help people see and enjoy color.

Papers with light color values have the least effect on ink colors. The darker and more intense the paper color, the more it will affect the color of ink. Papers in intense primary hues — blue, yellow, green, and red, for example — interact most directly with ink colors to form new color partnerships. Dark papers have a profound darkening effect on inks of even very different hue. Red and green, normally opposites, will both look similarly dark gray on dark gray paper.

I like papers of similar value, light or dark, because they have the most subtle or quiet interaction with each other. Their soft edges distinguish yet unify a multi-pieced project.

When the content of a project has a part that is much different or more important than others, I choose a paper that stands out from the others in value or hue. This is done all the time for covers or the financial section of annual reports. But consider doing it atypically. Print the entire annual report on colored papers and the financial section on white, for example.

I use color like spice in food. A variety of subtle or bland flavors are brought to life with a dash of spice. Similarly, if I decided on several subtle earth-tone papers for a project, I'd pick a spot of lime green or some other strong ink to bring them to life.

R E D

Demo 1.4.2

Printing a single ink color (red) on duplex paper (dark blue on one side and light gray on the other) changes the appearance of the red ink printed on opposite sides.

BLUE

Paper is shipped and sold in cartons. Using less than a full carton may result in a "broken carton" charge that will increase your paper cost. Check with your printer about the required quantity of each proposed paper color prior to printing.

Matching a single colored ink, such as a corporate color for a logo, on different colored papers may prove to be difficult if not impossible. Inquire beforehand about your printer's ability to adjust ink formulation for various colored papers.

Manufacturers often change paper colors, deleting unpopular colors from their line. Make sure your paper swatch book is current, or the color you select may no longer be available.

Quantity of papers, few - many

Hues of papers, primary - neighbor - opposite

Values of papers, dark - light

Texture of papers, smooth - rough

Intensity of papers, intense - subdued

Demo 1.4.3

Printing a single ink color (blue) on three light, muted paper colors has little effect on the color of the blue ink.

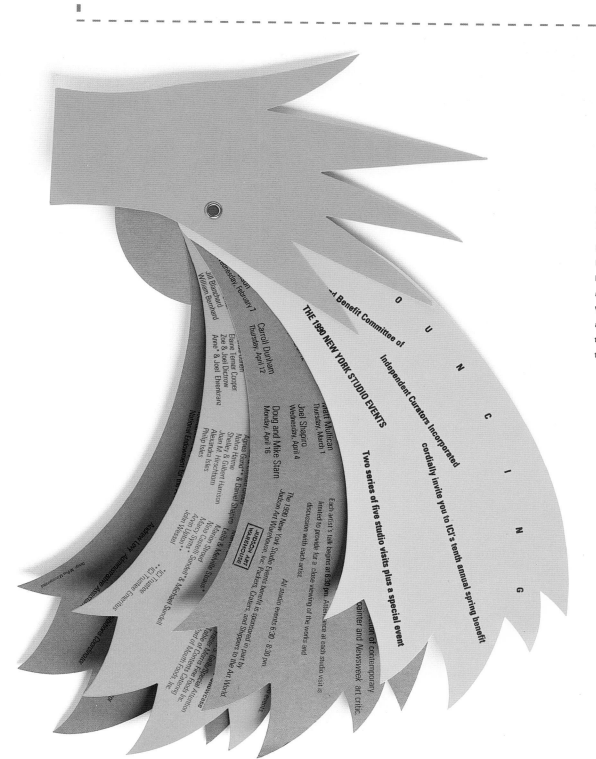

1.4.1

M Plus M
Incorporated

Independent Curators
Incorporated studio
benefit announcement,
approximately 7" x 12".
Various paper colors
are die-cut and bound
together with a rivet so
that the pages fan out.

Ink Color Change

Print multiple pieces or signatures, each with a single, different ink color.

My wife and I are quite different, in many ways opposite. But in our differences we balance each other and combine to form quite a team. Carefully wedding different ink colors on several single-color printed pieces may form an equally strong combination.

If a project calls for printing several individual pieces that will be seen together, or several signatures that will be bound together, each piece can be printed in a single, different ink color. When the final pieces are drawn together, the combined effect is a variety of single-color pieces which can be very impressive.

One color of ink isn't significantly more expensive than another. Printing a one-color project with blue ink costs the same as printing it with black or orange or gold. Printers generally stop and clean, or wash up, their press between jobs. This includes cleaning out all of the ink color from the previous job. The clean ink fountain creates an opportunity to change ink colors. The different ink color specifications for each piece must be specified on the art, otherwise the printer will assume that the entire job prints the same color.

By planning collating and binding, individual one-color sections can be joined together in a specific color sequence. This is often done on large books and annual reports. It is also done by successively changing the trim size of inserts in a pocket folder. In this instance, each successive insert is taller than the one before it, exposing the different ink color on each successive insert.

I avoid defaulting to very dark or otherwise very similar ink colors on separate pages. They look too much the same. An overly subtle ink color difference on separate pages may look like a mistake.

Color coordination is key to the success of this strategy. A random selection of hues, values or intensities makes the pieces look as if they don't belong together. A disorganized, confused appearance is the result. An organized system of colors that have a common hue or value characteristics will tie separate pieces or pages together.

I often select a palette of several ink colors that combine to express the character of a client or their business and use it on all their printed pieces. The palette guarantees that designs printed at various times will have a coordinated look without becoming monotonous.

GREEN

BL GREEN

BLUE

Demo 1.5.1

Printing three single but different ink colors that are similar in hue (green, blue-green and blue) on separate projects unifies the different printed pieces.

T A N

BL GRAY

PINK GR

Some quick printers
prefer to print only
black. This saves them
press cleaning time
between jobs. Watch
out. A printer like this
will often charge a
premium to change ink
colors on separate
runs.

Quantity of inks, few - many

Coverage of inks, small - large

Hues of inks, primary - neighbor - opposite

Values of inks, dark - light

Intensity of inks, intense - subdued

Demo 1.5.2

**Printing three single
but different ink colors
that are the same value
and intensity (tan,
blue-gray and pink-
gray) on separate pro-
jects unifies different
printed pieces.**

1.5.1

Dan Bittman,
Design Team

Lou Specker letterhead,
envelope and card.
A different ink color is
printed on the back of
each piece: yellow on
letterhead, blue on
envelope, and red on
business card.

1.5.2

Douglas Wadden

The same image prints
in a different ink color
on the cover of each
piece. Translucent
paper allows inside
imagery, different on
each brochure, to show
through and add variety
in addition to the
changing color.

Different Sides Print a Different Color

Print a different color on each side of a sheet.

Every coin has two sides. Well, I'm not a coin collector, but as a graphic designer I am sure that every sheet of paper has two sides. If you are printing on both, then the color miser can seize the opportunity to squeeze the most from each penny.

Most jobs print on both sides of a sheet of paper. This creates an opportunity to print each side with a different colored ink, a literal doubling of your color money.

Most printers first print one side of a sheet, stop, reconfigure the press, then print the other side of the sheet. During this change the opportunity exists to change ink colors at little or no additional cost. The exception to this is the perfecting press which prints both sides of the paper at the same time, but even the perfector uses two separate ink fountains which can easily contain two different ink colors. In either case, selecting a different color for each side of the paper is a viable option. The different ink color specification for each side must be specified on the art, otherwise the printer will assume that the job prints the same color on both sides. Done correctly, the contrast between the two colors on opposite sides will make a single-color job look like two-color.

I have shaved cost on book projects by specifying different colors on opposite sides of a 16-page signature. It makes the book appear to be two-color with alternating spreads being different colors.

Because opposite sides of a page are seldom seen at the same time, I try to design in a way to see them both together. Otherwise the second color may go unnoticed. By die-cutting or folding I can expose both sides of the page at the same time, emphasizing the color difference of the two sides and adding impact. However, it would be foolish to try to save money by adding an expensive die-cutting step unless the project already requires it.

Our eyes can detect millions of colors, but our minds carry only a half dozen or so names to define and remember them all. Because the different color is on the opposite side of the page, decisive color selection is needed for this technique to work well. If the two sides can be seen together, then the opportunity exists for the subtle color interaction of similar hues or values. If not, then colors that are decisively different in value or hue should be chosen.

PURPLE

BLUE

Demo 1.6.1

Printing a single but different ink color (blue and purple) on opposite sides of the paper is emphasized by folding so that both ink colors are shown simultaneously. Direct comparison enhances a color selection that is similar in hue.

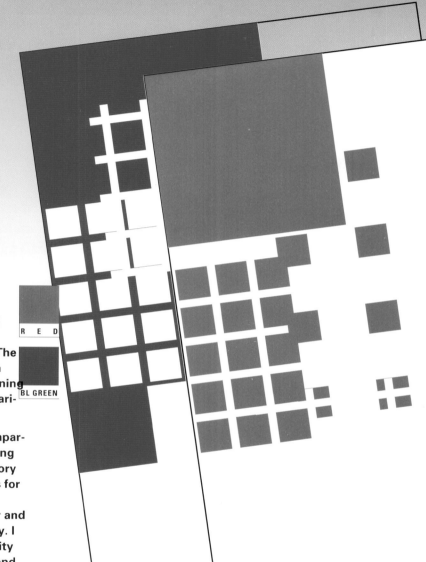

When direct comparison is possible, I enjoy choosing colors that are near neighbors in value, hue or intensity. The soft and subtle color differences are a source of real pleasure to me. Positioning subtly different colors to invite comparison helps others see and enjoy them.

If the opportunity for direct color comparison is not available through die-cutting or folding, I will stimulate color memory by selecting distinctly different colors for opposite sides. This emphasizes that opposite sides are not the same color and becomes a source of surprise and play. I pick opposites in value, hue or intensity to form the most distinctly different and vivid impressions.

Be careful to allow enough drying time between sides on the press run, especially if one color is light and the other dark or if the colors are complementary. As the paper stacks up at the end of the press, the wet ink may offset, rubbing off onto the dry side. This will be especially noticeable along edges where pressure from the trimmer is most likely to cause offsetting. You may need to allow an extra day, or days, for the ink to dry between printings.

Quantity of inks, few - many

Coverage of inks, small - large

Hues of inks, primary - neighbor - opposite

Values of inks, dark - light

Intensity of inks, intense - subdued

Demo 1.6.2

Printing a single but very different ink color (red and blue-green) on opposite sides of the paper emphasizes the ink color difference when direct comparison is not possible.

1.6.1

Douglass Scott,
WGBH

Living Against the Odds
pocket folder, 9" x 12".
Different colors printed
on opposite sides: sim-
ulated Day-Glo orange
over matte black is
accentuated by angular
die-cut shape. Die-cut
and color create an
impression of threat
appropriate to title.
Exposing front and
back at the same time
through use of fold and
die-cut emphasizes the
dramatic hue and
value difference.

1.6.2

M Plus M
Incorporated

Poster, 20" x 20".
Different colors printed
on opposite sides, black
over yellow, are dra-
matically different in
hue and value. The
color choice calls
attention to the color
difference on a piece
that does not invite
front-to-back compari-
son. Bold graphic
shapes print in black,
stressing the graphic
quality of the symbols,
while the light yellow on
the reverse side
enhances the textural
quality of the type.

91
the
01.
02.
03.
04.
05.
06.
07.
08.
09.
10.
11.
12.
13.

14. Capitalism
15. Censorship
16. Cheap champagne
17. Cheating
18. Chemical leaks
19. Child abuse
20. Conservatism
21. Corruption
22. Deforestation
23. Discrimination
24. Dishonesty
25. Drug addiction
26. Drug cartels
27. Embezzlement
28. Extortion
29. Famine

45. Ignorance
46. Incest
47. Infomercials
48. Insensitivity
49. Insider trading
50. Intolerance
51. Junk bonds
52. Junk food
53. Land fills
54. Larceny
55. Loitering
56. Loss of laughter
57. Money laundering
58. Monopolies
59. Mugging
60. Murder

76. Robbery
77. Sexism
78. Shortsightedness
79. Slavery
80. Solicitation
81. Televangelists
82. Terrorism
83. Torture
84. Toxic waste
85. TV dinners
86. Tyranny
87. Vagrancy
88. Vandalism
89. Vegetarians
90. War
91. Xenophobia

Preprint/Imprint

Print a single ink color and imprint a different single color later.

The fable of the ants dutifully preparing their winter banquet is a study in planning ahead. This insect foresight contains an impor-tant lesson for the color-wise if I can just get my ear low enough to listen.

Many communications have some repetitive information, such as logos or other imagery. When budgets are tight, this consistent information may be preprinted in great quantity, stored like the ants' supper, and brought out to be imprinted with more specific information at the appropriate time. Letterhead is a classic example of this, the masthead for a newsletter is another example; a little imagination will suggest other opportunities. Anything printed twice is a chance to multiply colors at little cost.

Paper is fed into sheetfed printing presses from large stacks or skids. While the paper on the skid is usually blank, there is no problem if the paper already has printing on it. Printing onto previously printed sheets is called imprinting or overprinting. It often makes sense to print a large quantity of one color of a project, storing most of the press run for future use. When the preprinted sheets are removed from storage to be imprinted, they may be printed with a new ink color, making a one-color job look like two-color. The main technical concern with imprinting is registration. Previously printed paper may shrink or stretch with changes in humidity over time, making tight registration unlikely. Leaving preprinted sheets untrimmed will facilitate future imprinting.

Typewriters and laser printers are office printing devices also designed to accept preprinted sheets. Papers for these printers are available at paper supply stores with color gradations, color solids, patterns, and textures already printed on them. While they cost a little more, these imprinted papers can add to the message. A preprinted parchment texture or printed color border can create just the right foundation for a certificate or award.

Careful color planning will make the most of imprinting opportunities. Select preprinted and imprinted colors with a clear difference in value or hue. If you use colors that are too similar, the two printings may look like a mistake rather than a decisive choice. When imprinting with a laser printer or copier, avoid making the preprinted color black, since most laser printers print using black toner. In this case, if you use black as your preprinted color, you are wasting time and money.

Whenever I have to design a letterhead or news release, I avoid black in my color selection. I know I'll get black for free when it is imprinted.

Storage and warehousing costs can eat up the savings generated by imprinting. Check with the printer.

Quantity of papers, few - many

Hues of papers, primary - neighbor - opposite

Values of papers, dark - light

Texture of papers, smooth - rough

Intensity of papers, intense - subdued

Quantity of inks, few - many

Coverage of inks, small - large

Hues of inks, primary - neighbor - opposite

Values of inks, dark - light

Intensity of inks, intense - subdued

T A N

BLACK

Masthead

Demo 1.7.1

Printing tan ink and later imprinting with black ink gives the look of a two-color job.

Jewish Hospital HealthCare Services

News Release...

502 587-4230 | fax 587-4784 | Public Relations Department, 410 First Street Louisville, KY 40202-1886

Regional Network
Jewish Hospital
Clark Memorial
Hospital
Four Courts
Senior Center
Frazier Rehab Center
Jewish Hospital
Shelbyville
Outpatient Care
Center
Pattie A. Clay
Hospital
Scott Memorial
Hospital
Washington County
Memorial Hospital

Affiliates
Jewish Hospital
Foundation
JH Properties
MedGroup
Management
SKYCARE®

1.7.1

Priscilla Fisher,
Zender +
Associates, Inc.

Jewish Hospital
HealthCare System
news release,
8.5" x 11".
Preprinted light purple
masthead is imprinted
with black as neces-
sary. The light purple
preprint is a decisive
value contrast for the
black imprint. The line
screen gradation adds
to the softness of the
light color, extending
the number of light val-
ues, adding further
contrast for the eventu-
al imprint.

Specialty Inks

Print using special ink colors.

Neon lights fascinate me. It's light that flows and bends and glows. Neon's special qualities attract people and communicate in ways that normal light cannot rival. Special inks have the same power to attract and communicate at no extra cost.

Typically, inks comprise vehicle and pigment, but there are inks that have more. These special inks have additional ingredients to produce outstanding effects. Although special inks may require special handling or even special press equipment, the result is impact that normal inks just can't match.

Special inks include metallics, Day-Glos, foils, varnishes, tinted varnishes, and opaque inks. While most of these are applied in basically the same manner as traditional inks, some require special handling on press. Metallic inks tend to be the most opaque of all inks while Day-Glo are notoriously transparent. Metallics lose most of their metal look when printed on uncoated paper and may interact well with other inks. Metallics also lose much of their metallic quality in halftone tints. Varnishes and tinted varnishes have virtually no pigment but are designed to produce a more glossy or matte appearance. They too have little impact on uncoated paper. Opaque inks effectively block the color of the paper stock making them especially effective on dark colors. Special coatings, such as UV, and transferable ink films, such as foil stamping, require special press equipment for application. Foils are actually thin ink films that are transferred using heat and pressure. They come in an amazing variety of colors and effects. Check with the printer before selecting a special ink to check out options and avoid problems.

Some color systems include specialty inks and some do not. Both the Pantone and Toyo ink companies make specialty ink formulas and offer swatch books which describe them.

I like to order my own specialty inks. I've seen varnish mixed with silver ink to create a pearly semitransparent varnish that was printed on translucent paper. This kind of exploration really calls for a talk with your printer. You might try to mix the impossible.

Metallic inks are beautiful in their color subtlety, being mostly medium to dark in value and unsaturated. This is due to the fact that most metallics have a silver/gray base. Day-Glos, on the other hand, are uniformly light in value and bright in intensity. This makes them unsuitable for large quantities of small body copy. Foils come in a wonderful diversity yet share the common trait of great opacity, while varnishes are so light that they are barely visible.

I tend to select special inks when they relate in some intriguing way to the content of my project. I once used Day-Glo orange on an annual report for a coal company. It helped communicate the heat potential in coal and was a nice contrast to the matte black ink that pictured the coal itself. I'm equally intrigued with selecting a special ink to create irony, like printing a massive rock or other heavy object in a varnish.

Metallics lose much of their sheen when printed as screen tints, as halftone photos or on uncoated paper. If you want your metallic ink to have a metallic sheen, print it solid on coated paper.

Day-Glo inks are notoriously transparent. They may require a double pass to really work, which will drive up your cost.

OPTIONS;

Quantity of inks, few - many

Coverage of inks, small - large

Hues of inks, primary - neighbor - opposite

Values of inks, dark - light

Intensity of inks, intense - subdued

PEN PLUS INC.
2-1-15-108 TAKANAWA
MINATO-KU, TOKYO 108
TELEPHONE 03.3444.9128
FACSIMILE 03.3447.5074

HARUMI TSUDA

PEN PLUS INC.
2-1-15-108 TAKANAWA
MINATO-KU, TOKYO 108

TELEPHONE 03.3444.9128
FACSIMILE 03.3447.5074

1.8.1

M Plus M
Incorporated

Pen Plus Inc. letter-
head, envelope, card.
Special Day-Glo orange
ink is printed on
embossed white paper.
The bright ink is a dra-
matic contrast to the
subtle raised surface of
the embossing.

1.8.2

M Plus M
Incorporated

Independent Curators
Incorporated
announcement
4″ x 11″
Printing a foil stamp
with multi-colored rain-
bow quality adds sever-
al colors for the price
of one.

Independent Curators Incorporated 15th Anniversary Benefit Exhibition and Silent Auction

27 October
through
1 November
1990

Hosted by
Bess Cutler
Gallery
593 Broadway
(between Houston
and Prince Streets)

Over 150 works
in all media by
an international
group of
younger as well
as established
artists from ICI
exhibitions.

Checklist and
bid-by-mail
forms are
available.

Benefit Party
Thursday
1 November
Cocktails, Silent
Auction, Dinner

Viewing and Bidding Hours

Saturday
27 October
10:00 - 6:00

Sunday
28 October
Noon - 6:00

Monday
29 October
10:00 - 6:00

Tuesday
30 October
10:00 - 6:00

Wednesday
31 October
10:00 - 6:00

Thursday
1 November
10:00 - 2:00

For more
information
please call
Mary LaVigne
at ICI
212.254.8200

ICI is a
non-profit
organization
dedicated
exclusively to
organizing and
circulating
traveling
exhibitions of
contemporary
art.

1992

Annual

Report

*Bringing Research
to Market*

LILLY

Lilly Industries, Inc.

1.8.3

Priscilla Fisher,
Zender +
Associates, Inc.

Lilly annual report
cover, 8.5" x 11".
Special metallic ink is
appropriate for industri-
al coatings manufactur-
er. A matte varnish,
which de-emphasizes
the metallic in the cen-
ter, emphasizes metallic
sheen on the border .

Other Processes

Other production processes open up color opportunity.

I shower. When I shower I pray. I am always looking for the chance to turn something I have to do into something I want to do. The same principle works in design. Turn a necessary part of the production process into an opportunity to expand color.

While most of this book is about putting ink on paper, there is more to most graphic design projects than just ink and paper. A variety of processes are used in the production of a given project. While not all of these techniques are inexpensive in themselves, in the right circumstance, any one of them can become an opportunity for cheap color variety.

Embossing presses an image into the paper, raising some parts and lowering others. It uses no ink and makes no color mark, but the shadows it creates make subtle variations in the paper value. Since embossing relies on shadow to create its image, it works best on white paper. An embossed image on dark or black paper is hard to see because gray shadows don't show up on paper that is as dark as the shadow. Because embossing requires a special metal die to mold the paper, it is slightly more expensive than printing with ink. If the embossed image is chosen strategically, a logo for example, the cost of the die may be spread over several projects.

Die-cutting similarly leaves no ink mark. A metal die cuts part of the paper, leaving a subtle line or a hole. Die-cutting is done to make pocket folders, divider page tabs or perforations. If a project requires any of these features, die-cutting special additional shapes can be done for little or no additional cost.

A drilled hole is similar to die-cutting, but a hollow drill bit is used to make a hole in an entire stack of paper. Since drilling requires no die and can cut through an entire stack of paper at one time, it is cheaper than die-cutting.

A sticker is just an offset printing job printed on an adhesive-backed paper. The paper could have a backing that is peeled away to reveal the adhesive or require moistening like a postage stamp. When preprinted in large quantity, stickers are an easy way to add a spot of color variety to nearly any project.

Sewing is used in some forms of binding. Paper is sewn together with thread, just like cloth. The thread can become a color accent that binds parts of a project together.Specialty papers can add color and life to an image. Many recycled papers contain colored flecks of cotton fiber or other papers, adding color at cost often below that of normal white paper. Metallic and mirror-finish papers are available but cost more. Translucent papers, also costing a little more, allow images to show through. These papers are generally light gray or white. They lighten even the darkest color beneath them.

I especially like the layering potential of translucent paper. I think it is used well when the controlled interaction between two parts of a message will clarify and enhance the message, like the interaction between a structured dot grid and an organic leaf. Translucent paper has the ability to separate and to join images at the same time. I think many other specialty papers, like mirrored papers, are more limited in their usefulness because their effect is so powerful and specific.

All of these specialty papers are more expensive than normal offset paper, but the dramatic effect can be worth the cost.

Cost Comparison: 10-75% more than benchmark, page 13.

1.9.1

Dan Bittman,
Design Team

Gerardo Ramundo.
Master Tailor. Business
card, 2" x 3.5".
Red thread is sewn
through the card,
adding an apt spot of
new color.

Michael McGinn,
M Plus M
Incorporated

JCH Telegraphics
Announcement,
11″ x 11″.
The die cut adds the
image of a face and a
playful dimension.

JCH Graphics, noted for its high quality standards and craftsmanship in the typographic field for almost a decade, is proud to announce a bold new initiative in the graphics industry...the introduction of JCH Telegraphics.

As a division of the parent company, JCH Telegraphics has been created to meet the needs and challenges of your publishing and graphic future. It combines the resources of our traditional typesetting services with the remarkable power of the Apple Macintosh™ and the entire PostScript™ environment.

You need only look as far as your desktop and JCH Telegraphics to appreciate the graphic capabilities your Macintosh™ can provide to you. Just send us your Mac disk, or telecommunicate to us via modem, and have laser type from our Linotronic-300 returned to you at an affordable cost.

Our research and development department has been keeping up with and developing areas directly related to this important trend in the industry. We also offer enthusiastic customer and technical support in order to bring you the finest product and service.

JCH Telegraphics invites you to join us now. The trip into the future of publishing will be shorter with JCH Telegraphics.

JCH Telegraphics
31 East 28th Street
New York, NY 10016

Telephone
212-889-2500
Facsimilie
212-686-1206
Telecommunications
212-676-5739

This announcement was set in PostScript™ on a Macintosh™ SE and Linotronic-300 using 9/9 ITC Franklin Gothic Demibold.

M+M

wishes
you
happy
holidays

m plus m
incorporated
17
cornelia
street
new york
ny
10014

takaaki
matsumoto

michael
mcginn

1.9.3

Takaaki
Matsumoto,
M Plus M
Incorporated

M Plus M greeting card,
5" x 7.25".
The mirror-finish paper
adds dimension and
communication, making
the second "M" appear
by means of reflection.

2.

Two-Color Techniques

Cover large areas for maximum impact.

"And, paradoxical though it may seem, (the handicraftsman's) legitimate personal fancy has therefore even greater scope than is the case with those who are surrounded to the point of bewilderment by a complicated variety of possible choices." (Eric Gill, noted designer and typographer, speaking of the benefit of being limited by just two or three ink colors in "An Essay on Typography.")

A lot more can happen with two colors than with just one. This section explains various techniques which will maximize the impact of two colors. Again, each technique is itself a variable and has several variables associated with it. The matrix below illustrates that by adding one additional color the options increase so dramatically that bewilderment can stifle creativity. A designer with so many options needs criteria to guide the selection process. I always try to match the technique and its visual properties to the concept and content of the message.

Adding a second color to a design can add anywhere from 7% to 30% to a one-color printing bill. You may also pay more for a job that includes halftone images or tints, depending on how it is produced. Computer-generated film will create the least additional cost for halftones, while conventional stripping and screening will cost the most.

All cost comparisons are based on the cost of printing a benchmark project: 5,000 pages, 8.5 x 11", black ink on both sides, 70# white offset paper. The benchmark represents the lowest possible printing cost: $347. All comparisons are approximations. Contact your printer for an estimate on your project.

The two-color matrix adds four new techniques to the one-color matrix, for a total of thirteen options. Notice that each two-color option has two variable choices, one for each color, dramatically multiplying the number of choices.

Variables

Size	Large - Small
Quantity	Few - Many
Value	Dark - Light
Hue	R O Y G B V
Intensity	Dull - Bright

	Size — Large Small	Quantity — Few Many	Value — Dark Light	Hue — Red . Or . Yel . Gr . Bl . Violet	Intensity — Muted Bright
Reverse					
Halftone Tint					
Blended Fountain					
Color Paper					
Change Ink					
Change Backup					
PrePrint Imprint					
Special Inks					
Other					
Two Like Three					
Mix Tints					
Double Hit					
Doutone					

Two Match Colors

Mix two colors to make a third color.

Sale! Buy two, get one free. I'm not a big shopper, but I like a sale as much as anyone. That is literally what happens if you are a smart color shopper. Pay for two colors and get a third free!

Many projects that print two colors miss a great opportunity to make a third color because the two ink colors never touch. Any time the two colors are mixed, they merge to form a new, third color. This principle of color mixture is a simple but powerful way to increase color impact.

All inks have some degree of transparency. When two transparent ink colors are laid over each other, they merge to form a new, third color. It is sometimes difficult to anticipate exactly what the third color will be, but an ink drawdown overlapping the two proposed colors will demonstrate the mixture.

It is also possible to overprint transparent and opaque or metallic inks for a different effect. In this instance the transparent ink can print over the more opaque one, serving to tint it. Printing the opaque ink over the transparent one will tend to mask any noticeable color difference. Be sure to clearly specify on the final art how and where you intend two colors to overlap, or the printer may become confused.

Demo 2.1.1

Overprinting two match primary colors (red and yellow) forms a new color, orange.

R E D

YELLOW

The more you know about color mixing, the better you'll be able to anticipate the result of overprinting two colors. Experience and a little sketching with paint, marker or colored pencil will refine your prediction. Mixing primary hues produces secondary hues; mixing complements produces gray or black. Mixing any color, other than a near neighbor, results in a distinctly different hue. Even black ink can be affected by the overprinting of a second ink color. A strong hue like red tints the black. If you use the red-tinted black and the untinted one next to each other, the difference will be clear and the result beautiful.

When an area of color is surrounded by a strong color field, an optical phenomenon called color subtraction occurs. The surrounding hue, acting upon the smaller area, subtracts its hue from the small spot. For example, a small purple area (a mixture of red and blue) surrounded by blue will shift dramatically toward the red. The surrounding blue seems to suck the blue out of the purple, emphasizing the red. This effect, combined with creative color mixing, gives the inventive designer ample room for producing dramatic and expressive effects.

I like creating color mixtures that yield unexpected results. On a recent project I selected yellow ochre and purple inks that combined to form black. It is hard to believe that those two colors would become so dark, but they did.

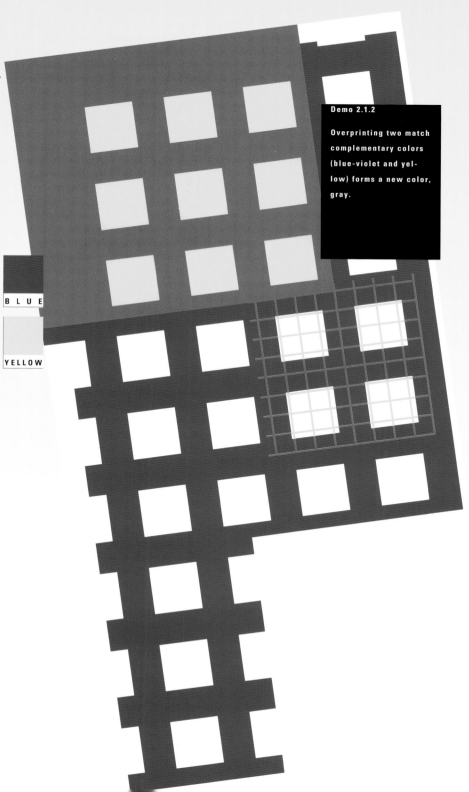

Demo 2.1.2

Overprinting two match complementary colors (blue-violet and yellow) forms a new color, gray.

BLUE

YELLOW

Some inks, particularly metallic, do not mix well on press. Custom formulations can help. Consult with your printer.

Demo 2.1.3

Overprinting a match color (red) over black gives the black a distinctive reddish cast.

R E D

BLACK

Demo 2.1.4

Surrounding the mixture (violet) of two primary colors (magenta and cyan) with each of the primaries makes the violet appear as two different colors: blue-violet in the magenta area and red-violet in the cyan area.

MAGENTA

BLUE

OPTIONS;

Type of halftone screen, dot - line

Hues of inks, primary - neighbor - opposite

Values of inks, dark - light

Intensity of inks, intense - subdued

Two Match Colors

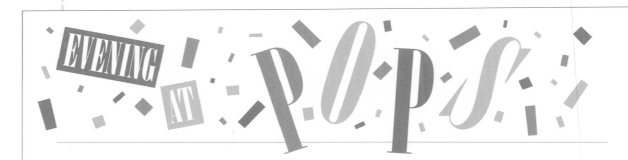

2.1.1 A & B

Douglass Scott,
WGBH

POPS envelope and letterhead, 9" x 12" and
8.5" x 11".
Tints of two colors are
overprinted to make a
third color: red and blue
make purple on the
envelope, while red and
yellow make orange on
the letterhead.

WGBH Boston
125 Western Avenue
Boston Massachusetts 02134
617 492 2777

Funding for Evening at Pops
is provided by public television stations
and by a grant from
Digital Equipment Corporation
digital

A joint production of
WGBH Boston and the
Boston Symphony Orchestra, Inc.

WGBH Boston
125 Western Avenue
Boston MA 02134

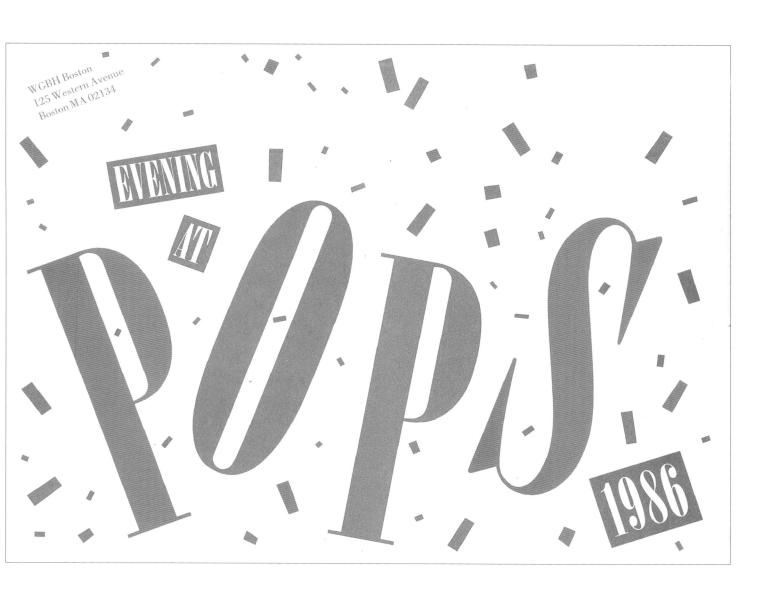

Two-Color Halftone Tints

Mix two color screen tints to make hundreds of new colors.

"One + One = Three or More." Josef Albers's twentieth-century math summarizes an unlikely fact: In color, two definitely result in three or more.

Halftone tints rely on the phenomenon of optical blending to produce a rich variety of tints from one color. By mixing halftone tints of two different colors, a vein of bountiful color variety is tapped — sort of the color equivalent of striking it rich.

Halftone screen tints are patterns of tiny dots, shapes or lines. A shape, type or photo may be printed with halftone tints of two different ink colors (hues). Any combination of tints is possible, 35% red and 70% yellow for example, though if one of the colors is solid, or 100%, the presence of the other color will be minimized. When overlapping halftone tints, care must be taken to minimize moiré by adjusting screen angles.

You can specify a two-color screen tint combination to the printer by marking the percentages of each color on the final art. However, determining how the specified combination will appear is difficult. There are few references to guide your choice. The book *Color on Color* is one reference that will help.

Two-color screen tints may be specified on the computer with appropriate software commands. But take care when you do it yourself to confirm that the screen angles are optimized.

I like to do things like printing a rectangle with 100% of one color, yellow for example, and 50% of the second color, black for example, while reversing type out of the black rectangle only. The result is yellow type reversed out of a dark greenish-gray rectangle and no screen angle problems. That's because one of the colors is 100%, no dot.

Knowledge of color theory is critical when mixing tints of two colors. Selecting hues that are near neighbors on the color wheel will have a monochromatic result with little color variation. Conversely, selecting primary hues will result in a secondary mixture that is very different from either parent, creating a third color from the original two. As the two selected colors drift from pure primaries, the resulting mixture will be less identifiable as a clear secondary, but still clearly different. Mixing tints of chromatic opposites will result in various grays, browns or black. In any case, the greatest variation in color hue occurs when the two selected hues are dissimilar.

Demo 2.2.1

Printing tints of two ink colors, near neighbors on the spectrum (green and blue-green), creates little variety when mixed as tints. A rectangle 75% green is not noticeably different than a mixture of 25% green and 50% blue-green.

GREEN

BL GREEN

The greatest potential variety of hues occurs when one or both of the two hues are a smooth gradation or blend. The blend will display a smooth sampling of nearly every possible tint combination. Incredible variety from just two colors.

I think it's fun to combine a gradation of a dark color with solids or tints of a lighter second color. The light color seems to emerge from the darker one. I often make the gradation cross over spots of the second color to interrupt and accentuate the color change.

I also like overlapping gradations of two different screen types, such as dot and line. It's a creative way to avoid moiré. Or, for screens of the same type, I'll specify two halftone tints in drastically different screen frequencies, a 30-line plus a 120-line screen for example, avoiding moiré and creating a striking tint.

In illustration software programs, you can create a blend of two color shapes. This will result in a tint combination palette with a rich variety of mixed color swatches from which to choose.

R E D

YELLOW

Demo 2.2.2

Printing tints of two primary ink colors (red and yellow) creates a range of dramatically different third colors (red-orange, orange, yellow-orange).

Two-Color Halftone Tints

Continued.

PITFALLS:

You should anticipate moiré. Some moiré texture is present in any screen tint combination, but will increase with improperly aligned screen angles.

Trapping is an issue wherever two colors must butt fit. You don't have to worry about trapping unless you are producing your own final film, usually on computer. It's a deep subject. Consult a manual.

Demo 2.2.3

Printing tints of two complementary ink colors (purple and ochre) creates a variety of gray-browns and purple-browns when mixed as tints.

OCHRE

PURPLE

LT BLUE

OCHRE

Sizes of tints, small - large

Quantity of tints, few - many

Value of tints, dark - light

Frequency of halftone screen, dpi

Type of halftone screen, dot - line

Hues of inks, primary - neighbor - opposite

Values of inks, dark - light

Intensity of inks, intense - subdued

2.2.1 A & B

Terry Swack,
Terry Swack
Design
Associates, Inc.

The Rule Book brochure, 5.5" x 8.5". Black and yellow inks are combined using screen tints. A spread dominated by black has a dark yellow area with bright yellow numbers. Notice how the black turns the yellow green/brown. The next spread has a predominance of yellow offering a dramatic value contrast.

Rule Broadcast Systems was founded on a handful of fundamental principles of doing business in video equipment rental. We call these principles The Rules, and they mean you get the equipment you want, the service you need, and the professionalism that makes you want to put us on your team every time.

play by we the rules

(4)

1 Brand-new equipment is the only equipment worth renting.
Evolving technology makes gear obsolete faster than ever. We can guarantee you the latest models in the best condition because we retire all pieces before they're eclipsed. Our cameras, for example, are pulled from circulation at the two-year mark or earlier. Manufacturers know we want their newest products, so we're usually first in line.

2 Choice is a part of the package.
When you want specific gear, you should be able to get it. You can count on us for both breadth of selection and depth of inventory. In fact, we've got the largest rental inventory in New England.

3 Reliability is our concern, not yours.
Our factory-trained maintenance staff checks all equipment in and out and maintains it to our standards — the most exacting in the industry. When we issue gear, you know it's road-worthy.

4 Service is a full-time commitment.
In a crisis or on a whim, you can call on us no matter where or when. We offer you 24-hour beeper access to our service department. Staff and vehicles are always ready for your call.

5 Equipment rental is our only business.
We don't believe in competing with our clients, so we're not involved in production. Our one mission is renting you the newest and best.

6 There's no substitute for experience.
With more than twelve years in the rental business, we've fine-tuned systems and procedures to make the process run smoothly. We can anticipate potential problems before they have a chance to start.

7 Reputation counts.
In a word-of-mouth industry, reputation is more than a matter of pride. We work hard to exceed your expectations, and that helps you look better than ever to your own clients.

Cameras include
 Sachtler 18 or 20 tripod,
AC power supply and
 3 batteries.

cameras

Broadcast

Sony BVW-590 600
BVP-90 3-CCD FIT camera with
BVV-5 Betacam SP onboard deck

Sony BVW 400A 525
3-CCD FIT Betacam SP camcorder (unibody) with
ClearScan and EVS (Enhanced Vertical Definiton System)

Sony BVW 400 515
3-CCD FIT Betacam SP camcorder (unibody)

Sony BVW-570is 500
BVP-70is 3-CCD FIT camera with
BVV-5 Betacam SP onboard deck

Sony BVW 300A 495
3-CCD IT Betacam SP camcorder (unibody)

Sony BVW-507A 485
BVP-7A 3-CCD IT camera with
BVV-5 Betacam SP onboard deck

Sony BVP-90 450
3-CCD FIT camera - over 800 lines resolution

Sony BVP-70is 375
3-CCD FIT camera

Sony BVP-7A 360
3-CCD IT camera with new HyperHAD chip

Ikegami HL-55 350
3-CCD FIT camera

Industrial

Sony EVW-327A 230
3CCD HI-8 camcorder. Consists of DXC-327A
camera and on board EVO-9000 HI-8 deck.

Sony EVW-300L 200
3-CCD industrial HI-8 camcorder (unibody)
with ClearScan, same specs as 327A

Toshiba IK-M40A 200
Hi-res (460 line) micro-miniature color CCD camera
with 10 shutter speeds, gen-lock, 4mm lens,
C mount adaptor, AC or DC operation

Sony DXC-327A 170
3-CCD IT camera with 700 lines resolution

Sony CCD V-5000 100
Single-chip HI-8 camcorder with on-board
time base error correction and digital effects

The First Family

Editor's Note: The Kennedys, a four-hour documentary about the family whose name has been synonymous with American politics for decades, launches the fifth season of public television's award-winning history series The American Experience. That same week, The American Experience follows the presentation of The Kennedys with two critically-acclaimed miniseries, the four-hour LBJ and the three-hour Nixon. LBJ returns Tuesday, September 22 and Wednesday, September 23 from 8 to 10pm; Nixon airs Thursday, September 24 from 8 to 11pm. Collectively, these 13 hours present portraits of political power during the critical period between World War II and 1974. (The American Experience also has a Dwight Eisenhower film and a series on FDR in the production pipeline.) In the following interview, 'GBH Magazine talks with Elizabeth Deane, executive producer of The Kennedys (and of Nixon), about the making of the film.

Q: So many books and TV programs have attempted to tell the story of the Kennedy family. Why another?

A: This is the first question that everyone asks—I asked it myself when the project came along. But to my surprise, nobody has done on film what we've now done: putting the entire story together in a substantial, carefully-researched series that tells the tale of the reach for the brass ring, for the presidency, from the father, Joseph P. Kennedy, down through his four sons.

We've brought a love of history, a lot of curiosity, a very clear-eyed view to the Kennedy story. We wanted to see the Kennedys in all their complexity, to make them rounded human beings, not tabloid cartoons or mythical figures.

Q: Why did you choose to take this approach, working from Joseph, the family patriarch, down through the sons?

A: This is a very American, very political family, and we wanted to tell their story against the backdrop of American politics. Focusing on the political led us to see that this family's story is one of a father and his sons. Rose Kennedy has

often been featured as the starring parent, but we see it differently. The structural spine of the film is Joseph, the father and master builder, who built a fortune and then aimed very high: he wanted to become the first Catholic president of the United States. And when his own presidential ambitions were ruined, he turned, one by one, to his four sons, pushing, driving, pressing them towards the presidency.

Q: Why do you think Americans today are still fascinated with the Kennedy family?

A: In part, I think, because the family itself has been very skillful over the years in keeping the legend alive. Joe Kennedy was superb at public relations. As we show in the film, he learned that in Hollywood. He knew how to hire the best photographers; he knew what Americans wanted to hear. So the Kennedy legend has been in part created and elaborated on by the family. On the other hand, a lot of the family's darker side has been revealed, which has turned some people away but also has kept a lot of people interested.

Whether or not you agree with their views, the Kennedys have come to stand for a certain kind of liberal ideal in American politics, even if they haven't always lived up to that ideal themselves. They've had an impact and they are fascinating.

Q: There has been a lot of speculation about President John F. Kennedy's sexual escapades in the White House. What does The Kennedys have to say on this subject?

A: We are very clear about the potential risk to national security that that behavior represented. We interviewed Judith Campbell Exner, and she is quite

a surprise. She is usually exploited in interviews simply as "the president's mistress," but we found her a thoughtful and articulate witness, someone who knew John Kennedy very well and who has some quite interesting things to say about him. He had a niche, she says, for every part of his life, and they didn't overlap. She's one of several women who talk about the way Kennedy lived his life in compartments.

Q: The Kennedys is being broadcast right in the heat of an election year. What lesson does it hold for us as we choose the next president?

A: I think that scheduling The Kennedys in a full week of films about presidents and power will provide viewers with an unprecedented opportunity to gain some insight into modern political life. All of these stories are about political power, about the reach for it, about what you do with it, and about what happens to you after you get it. With the Kennedys, it's a family reaching for it; with LBJ and Nixon, it's an individual.

Q: Putting together a film of this scope must be an undertaking. How were you able to pull so information together?

A: It's taken a long, long time and a very senior talented staff to put it together. And I'd like to that only public television could create such a gram, and only public television would devote hours to its broadcast. Only in public television could you find a superb executive producer like Crichton of The American Experience to sit wi and go over the piece frame by frame, to make strong as it possibly could be. I think that kind attention has made a big difference, and the r a strong piece that will be part of a powerful week of television.

The Kennedys
**Sunday, September 20 and
Monday, September 21
8 to 10pm on Channel 2**

The Kennedys is a co-production of WGBH Boston and Thames Television for The American Experience. The American Experience is a co-production of WGBH Boston. Thirteen/WNET New York and KCET/Los Angeles. Aetna continues a fifth season as the series' corporate underwriter.

Classic

Avery Fisher Hall is the setting for the 150th-anniversary season launch of America's oldest orchestra. This opening-night celebration, with conductor Kurt Masur and soprano Kathleen Battle center stage, includes selections from Prokofiev's Romeo and Juliet; Bernstein's Symphonic Dances from West Side Story and "Glitter and Be Gay" from Candide, plus songs by R. Strauss. And later this month (9/30), the New York City Opera: Cavalleria Rusticana/Pagliacci. John Eaton's acclaimed production set in turn-of-the-century Little Italy, airs on Live from Lincoln Center. These two season-opening specials are but a few of the classical gems available all year long on Channels 2 and 44—and on 89.7fm—as part of WGBH's ongoing commitment to keep classical music fresh and accessible to its viewer listeners. (See page 17)

*Live From Lincoln Center
New York Philharmonic 150th
Opening Night Gala*
**Wednesday, September 16
at 8pm on 2**

9:00 2 **Power, Politics and Latinos** (See highlight)(CC)(R 9/20 at 8pm on 44)
44 **The Miracle Planet** The Third Planet. A six-part exploration of Earth's dynamic systems. Tonight's program asks what craters and other geological features reveal about the birth of the planet. (CC)

10:00 2 **Listening to America with Bill Moyers** voices the concerns of Americans in this election year. (CC)(R 9/21 at 11:30pm on 2)
44 **El Matador** profiles a 17-year-old Mexican bullfighter.

11:00 2 **Are You Being Served?**
44 **Nightly Business Report**

11:30 2 **Inside Information** (See 9/5 at 2pm)

12:00 44 **Today's Japan**

16 Wednesday

MacNeil/Lehrer NewsHour (CC)

Nightly Business Report

The Wednesday Group (CC)
MacNeil/Lehrer NewsHour (CC)

Are You Being Served?

Live From Lincoln Center New York Philharmonic 150th Opening Night Celebration. (See highlight)(R 9/20 at 8pm on 44)
Fire on the Rim Fire Into Gold. This four-part series charts the effects of natural disaster on the peoples of the Pacific Rim. First up, the land riches that continue to attract people to the "Rim of Fire." (CC)

9:00 44 **Korea: The Unknown War** Many Roads to War. Six programs trace the origins and legacies of the Korean War. Tonight, the forces that led to the outbreak of war. (CC)

10:00 2 **Jacksonville Jazz XII** showcases the talents of vocalist Diane Schuur, the Chick Corea Elektric Band and other jazz artists at the 1991 fest. (R 9/17 at 4pm on 44, 9/18 at 12mid on 2 and 9/22 at 10pm on 44)
44 **Inside Information** (See 9/5 at 2pm)

11:00 2 **Are You Being Served?**
44 **Nightly Business Report**

11:30 2 **Great Steam Trains** Quest for Speed (See 9/12 at 9pm)
44 **The Wednesday Group**

12:00 2 **Great Steam Trains** Workhorses (See 9/12 at 9:30pm)
44 **Today's Japan**

Carmen Kids

Come see Greg Lee host a special live version of Where in the World Is Carmen San Diego?, with Carmen contest-winning kids from around New England participating, on Saturday, September 5 at 1pm at the CambridgeSide Galleria Mall!

17 Thursday

6:00 2 **MacNeil/Lehrer NewsHour** (CC)

6:30 44 **Nightly Business Report**

7:00 2 **The Thursday Group** (CC)
44 **MacNeil/Lehrer NewsHour** (CC)

7:30 2 **Are You Being Served?**

8:00 2 **This Old House** Steve searches a salvage yard for architectural details for the facade. (CC)(R 9/19 at 5:30pm on 2, 9/20 at 9am and 12:30pm on 44 and 9/21 at 10am on 44)
44 **The Metropolitan Opera Presents** The Ghosts of Versailles (See 9/14 at 8pm)

8:30 2 **Say Brother** Remembering Brother Malcolm recalls the life of slain leader Malcolm X. (R 9/20 at 5pm on 2)

9:00 2 **Mystery!** The Dark Angel. A young woman refuses to believe public rumor that her uncle is evil—until she becomes his ward. Peter O'Toole and Jane Lapotaire star in this Gothic thriller. (CC)(R)(VS)(R 9/18 at 1:30pm on 44 and 9/20 at 10pm on 2)

11:15 44 **Nightly Business Report**

11:30 2 **Are You Being Served?**

11:45 44 **The Thursday Group** (CC)

12:00 2 **NOVA** Hurricane! (CC)(See 9/15 at 8pm)

12:15 44 **Today's Japan**

18 Friday

6:00 2 **MacNeil/Lehrer NewsHour** (CC)

6:30 44 **Nightly Business Report**

7:00 2 **Christopher Lydon and Company** (CC)
44 **MacNeil/Lehrer NewsHour** (CC)

7:30 2 **Are You Being Served?**

8:00 2 **Washington Week in Review** (CC)
44 **Wilderness Alive** High Alaska. The wildlife and landscape of the state's mountain tundra. (R 9/19 at 7pm on 2 and 9/20 at 12noon on 2)

8:30 2 **Wall Street Week** (CC)

9:00 2 **Louis Rukeyser's 1992 Election Guide** Interviews with the presidential nominees and their representatives help viewers probe each candidate's economic, foreign and social policies.
44 **Hawaiian Legacy** documents the revival of traditional island crafts in contemporary Hawaii. (CC)(R 9/22 at 11:30pm on 2 and 9/24 at 3pm on 44)

10:00 2 **America Becoming** looks at the diverse nationalities, languages and religions that are changing our cultural make-up. (CC)
44 **American Originals** Saturday Night and Sunday Morning. Three programs celebrate the American experience through the traditional arts. Tonight's look at the rich musical heritage of African Americans celebrates blues, Juba dance and gospel. (R 9/24 at 4pm on 44)

11:00 44 **Nightly Business Report**

11:30 2 **Are You Being Served?**
44 **Christopher Lydon and Company** (CC)

12:00 2 **Jacksonville Jazz XII** (See 9/16 at 10pm)
44 **Today's Japan**

19 Saturday

6:30 2 **Nightly Business Report**

7:00 2 **Sesame Street** (CC)
44 **Nathalie Dupree Cooks for Family & Friends**

7:30 44 **Amish Cooking From Quilt Country**

8:00 2 **Sesame Street** (CC)
44 **Cooking with Kurma** (R 9/22 on 44)

8:30 44 **Marcia Adams' Heartland Cooking** (R at 1pm on 2, 9/20 at 9:30am on 44, 9/21 at 9am on 44 and 9/22 at 8:30am on 44)

9:00 2 **Sesame Street** (CC)
44 **Pierre Franey's Cooking in America** (R at 9:30am on 2)

9:30 44 **The Frugal Gourmet** (CC)(R at 4pm on 2, 9/20 at 11am on 44 and 7pm on 2 and 9/22 at 9am on 44)

10:00 2 **NOVA** Hurricane! (CC)(See 9/15 at 8pm)
44 **Julia Child & More Company** (R at 2:30pm on 2, 9/23 at 9:30am on 44 and 9/25 at 8:30am on 44)

10:30 44 **The French Chef**

11:00 2 **Destinos: An Introduction to Spanish** (See highlight, page 6)(CC)(R at 3pm on 44 and 9/21-25 at 12noon on 44)
44 **Film:** Jamaica Inn Daphne du Maurier's spooky tale of cutthroat thieves on the moors of Cornwall stars Charles Laughton and Maureen O'Hara. Alfred Hitchcock directs. (1939)

12:00 2 **Sneak Previews**

12:30 2 **The Joy of Painting**

2.2.2 A & B

Cathleen Damplo,
Douglass Scott,
WGBH

WGBH Program Guide,
8.5" x 11".

Green and black inks are mixed using various screen tint combinations. On one spread, light green dominates the top of the page; on another muted gray/greens highlight featured information.

LISTINGS 89.7

These complete chronological listings of the 89.7fm schedule for the month offer all individual titles for each day, with the exception of the regular news programs: *BBC Newshour* (weekdays at 6am), *Morning Edition* (weekdays at 6am), *All Things Considered* (Monday to Saturday at 5pm), *Marketplace* (weekdays at 6:30pm) and *Monitoradio Weekend Edition* (Saturdays at 6am). See grid on page 20 for quick reference.

89.1fm also broadcasts BBC World Service programs on a new outlet: the SAP channel on your stereo television or VCR. For a complete schedule, call 617-492-9254 between 9am and 5pm weekdays.

live Denotes live concert from WGBH studio
● Denotes probable hourly break

1 Tuesday

7:00 Morning pro musica Bach: Passacaglia and Fugue in c, BWV 582; Haydn: Symphony #96 in D ● Pachelbel: Canon; Bach: Toccata and Fugue in d, BWV 565; Starzer: 10 Dances ● Humperdinck: Hänsel and Gretel: overture; Children's Prayer; Bizet: L'Arlésienne: Suites 1, 2 ● Beethoven: Violin Sonata #9 in A, Op.47, "Kreutzer"; Milhaud: Le Carnaval d'Aix, Op.83b ● Falla: Three-Cornered Hat

12:00 Off The Record A *live* concert

1:00 MusicAmerica New Releases on CD. At 3pm, New York Cabaret Nights. A 13-part salute to the world of cabaret. Steve Ross hosts. Today, Sylvia Syms, Karen Akers and Lee Roy Reams [See story, page 18]

7:00 Eric in the Evening Tuesday Night Special/Worldwide Jazz — Live from Nick's Cafe presents pianist Oliver Jones and trio featuring drummer Ed Thigpen. [See story, page 19]

12:00 NightAir "Tommy" with The Who and the London Symphony Orchestra and Chorus

2 Wednesday

7:00 Morning pro musica J. Clarke: Suite in D, Vivaldi: Violin Sonata in A; Schubert: Fantasy in C, D.760, "Wanderer Fantasy" ● Bach: Sonata #1 in g, BWV 1001; Albrechtsberger: Concerto in E-flat for Jew's Harp, Mandera,

Orchestra ● Donizetti/Pasculli: La Favorita, Paraphrase; Vienna: Rosa; R. Strauss: Der Rosenkavalier Waltzes ● Ravel: String Quartet; Milhaud: Le Pauvre Matelot, Op.92 ● Sibelius: Symphony #2

12:00 Off The Record 12th-20th c chamber music

1:00 MusicAmerica Love Comes and Goes: Gershwin; Porter; Sondheim; Kern. At 3pm, New York Cabaret Nights, Pt. II. Skitch Henderson and Marian McPartland

7:00 Eric in the Evening Jazz

12:00 NightAir The weekly series Music of the Cinema kicks off with Franz Waxman, Pt. I

3 Thursday

7:00 Morning pro musica Gregorian chant; Vivaldi: Violin Concerto in G; C. P. E. Bach: Oboe Concerto in B-flat ● Locatelli: Oboe Sonata in D; Il Pianto d'Arianna; Frescobaldi: Capriccios ● Saint-Saëns: Introduction and Rondo; Capriccioso; Milhaud: Polka for "L'Eventail de Jeanne," Op.95; Mozart: Piano Concerto #15 in B-flat, K.450 ● Weill: Three Penny Opera Suite; Bartók: Rhapsody #1 ● Beethoven: Symphony #6

12:00 Off The Record 12th-20th c chamber music

1:00 MusicAmerica A Perfect Match. Dave McKenna-Dick Johnson; Ella Fitzgerald-Joe Pass; Tony Bennett-Bill Evans. At 3pm, New York Cabaret Nights, Pt. III features Michael Feinstein and Anne Francine.

7:00 Eric in the Evening Jazz

12:00 NightAir Theodorakis: "The Ballad of Mauthausen"

4 Friday

7:00 Morning pro musica Milhaud: Sonatine for clarinet, piano; Concerto for percussion, small orchestra, Op.109; Sonate, Op.112; L'Automne, Op.115 ● String Quartet #8, Op.121; Les Songes, Op.124 ● Piano Concerto #1, Op.127; Cello Concerto #1, Op.136; String Quartet #9, Op.140 ● Sonata in D of Baptiste Anet, Op.144; Pastorale, Op.147; Suite for violin, clarinet, piano; Suite Provencale, Op.152b ● Schickele Mix

12:00 Off The Record A *live* concert

1:00 MusicAmerica Presents: Great Voices Eileen Farrell. At 2pm, Puccini's "Manon Lescaut" with Jussi Bjoerling, Licia Albanese and Robert Merrill

7:00 Celtic Sojourn

9:00 Blues After Hours At midnight, Blues Playback: Black Top Records—Blues Pajama Party

1:00 The Jazz Gallery Kenny Burrell, guitar

5 Saturday

7:00 Morning pro musica Cage: In a Landscape; Mendelssohn: String Symphony #4 in c; Diabelli: "Easy pieces"; F. Couperin: La Francoise ● Bach: Concerto in d for 2 violins, BWV 1043; Diabelli: Sonatina in C, Op.151 #4; J. C. Bach: Bassoon Concerto in B-flat ● Meyerbeer: Le Prophète; coronation march; Mozart: Violin Sonata in G, K.379; Kodaly: Háry Janos Suite ● Bach: Variations on Balkan Themes; Prokofiev: String Quartet #2 in F, Op.92; Copland: El Salón México ● Cage: Mysterious Adventure; Kessler: Fantasy for oboe, piano; Bloch: Violin Concerto in a

12:00 The Folk Heritage Songs of Work

6:00 Garrison Keillor's American Radio Company From Symphony Space, NYC. Doky Brothers; Bob Elliott

8:00 BluesStage William Clarke; Queen Ida and her Bon Temps Zydeco Band

9:00 Blues After Hours At 11pm, Blues A to Z. Frank Frost

1:00 The Jazz Gallery Travel Light! Emil Gonsalves, saxophones; Albert Mangelsdorff, trombone; Roy Brooks, drums

6 Sunday

6:00 A Note to You The American Pianist: David Whitten discusses life of the pianist/teacher.

7:00 Morning pro musica Hildegard of Bingen; Kyrie; Marais: Suite in g; Handel: Flute Sonata #1 in a ● Bach: Cantata BWV 75, "Die Elenden sollen essen"; Sanz: Suite espagnole ● Mozart/Triebensee: La clemenza di Tito; Rossini: Un Petit Train de Plaisir ● Milhaud: Introduction and Marche Funèbre, Op.153; Beethoven: Violin Sonata #6 in A, Op.30 #1; Vaughan Williams: Fantasia on a Theme by Thomas Tallis ● Offenbach/Rosenthal: Gaîté Parisienne

12:00 International Performances From concert stages around the world

1:00 Classical Organ

2:00 Caravan Worldbeat

4:30 Soundprint Ye Shall Handle Serpents [See highlight, page 21]

4:30 Living on Earth [See highlight, page 21]

5:00 Arts & Ideas American Images: Winona LaDuke. From Genocide to Resistance: The Next 500 Years [See highlight, page 21]

6:00 Crossroads Multicultural newsmagazine

6:30 Horizons Teaching the Deaf: A Wall of Silence in a World of Sound [See story, page 21]

7:00 The Jazz Decades Lionel Hampton in Hollywood 1937; Clancy Hayes, Yank Lawson 1964; Dick Hyman Plays Fats Waller 1988

Live from Studio One

Members of the 89.7 Club are invited to the WGBH Radio studios in Allston for two live, on-air performances per membership year—a chance to watch the 89.7fm hosts in action behind the microphone and to hear great live music. These in-studio concerts are for 89.7 Club members and special friends of WGBH only. For details about how to attend in September, call the Member Hotline at **617-492-9254.**

8:00 Now's The Time Jazz and the Classics

1:00 The Jazz Gallery Labor Day Special. What's the difference between a jazz singer and a pop singer? Tune in/call in. Artist-of-the-Month: Joe Williams

7 Monday

7:00 Morning pro musica Lawes: Consort Sett a 6 in F; C. Stamitz: Duet in D; Graun: Oboe Concerto in c ● Geminiani: Concerto Grosso in d, "La Follia"; Haydn: String Quartet #45 in A ● Beethoven: Wind Quintet in E-flat; Britten: Simple Symphony; Schubert: Arpeggione Sonata ● R. Strauss: Till Eulenspiegel's Merry Pranks; Milhaud: Suité d Après Corrette, Op.161b; Scaramouche, Op.165b; Ball: Sinfonietta for Brass Band, "The Wayfarer" ● Gershwin: Second Rhapsody; Schuman: Symphony #10, "American Muse"

12:00 Off The Record 12th-20th c chamber music

1:00 MusicAmerica All That Jazz. Armstrong; Waller; Basie; Ellington; Eldridge; Peterson. At 3pm, New York Cabaret Nights, Pt. IV. Angelina Peaux and K.T. Sullivan

7:00 Eric in the Evening Jazz

12:00 NightAir "Oldies but Goodies" Special

8 Tuesday

7:00 Morning pro musica Renaissance dances; Loeillet: Flute Sonata in e; J. Benda: Harpsichord Concerto in G ● Mozart: Adagio and Allegro in f, K.594 ● Maxwell Davies: Dances from "The Two Fiddlers"; Milhaud: Cantate de l'enfant et de la mère, Op.185; Liszt: Symphonic Poem #9, "Hungaria" ● Haydn: "Theresienmesse"; Maxwell Davies: Farewell to Stromness ● Kinloche, his Fantassie; Dvorák: Symphony #9

12:00 Off The Record 12th-20th c chamber music

1:00 MusicAmerica The Birth of a Band! Quincy Jones; Clayton Hamilton Orchestra; Zim Zemarez; Maynard Ferguson. At 3pm, New York Cabaret Nights, Pt. V. McGuire Sisters.

7:00 Eric in the Evening Tuesday Night Special. Saxophonist Red Holloway

12:00 NightAir Nyman: "La Traversée de Paris"

9 Wednesday

7:00 Morning pro musica Frescobaldi: Canzoni; Allegri: Miserere; Telemann: Concerto a 6 in F ● Bach: Brandenburg Concerto #1 ● Suppé: Beautiful Galatea: overture; Chaminade: Valse Romantique; Dvorák: String Quintet in G, Op.77 ● Milhaud: Cortège Funèbre, Op.202; Rheinberger: Violin Sonata #1 ● Rachmaninoff: Piano Concerto #3

12:00 Off The Record 12th-20th c chamber music

1:00 MusicAmerica Trumpets, Trombones and Tubas. The Canadian Brass Ensemble; Bill Harris; Dizzy Gillespie. At 3pm, New York Cabaret Nights, Pt. VI, New York Cabaret Nights, Pt. VI. Margaret Whiting

7:00 Eric in the Evening Mambo Magic. Eric welcomes back co-host Marta Valentin to explore the origins of the mambo.

7:00 Eric in the Evening Jazz

Cooking with Classical Gas

WGBH Radio's traditions are firmly rooted in the presentation of classical music. On October 6, 1951, the station made its broadcast debut with a live Saturday-evening performance by the Boston Symphony Orchestra. Within nine months, 89.7fm had a listenership of 435,000 families, and sales of FM-receiving radios had surged by 25 percent. (WGBH's *Boston Symphony Orchestra* broadcasts had attracted such a following that Zenith Corporation even produced a table-top radio called "The Symphony.")

Since then, WGBH Radio's audiences for classical music programming have continued to grow, and as they have, 89.7fm's commitment to classical broadcasts has expanded and diversified with them. "Listeners rely on WGBH for the traditional," comments WGBH Vice President and Radio Manager Marita Rivero, "yet they know they can expect the unexpected, too, as we maintain our position on the cutting edge of exploring new classical artists, new compositions, new musical forms within a classical canon and new ways of presenting them."

This month marks the completion of Robert J. Lurtsema's 20th-anniversary year as host of *Morning pro musica*. The cornerstone of 89.7fm's classical-music program offerings, this early-morning staple serves up a respected blend of time-honored music as well as challenging forays into more contemporary compositions, along with news and weather updates. *Off The Record* showcases the best that New England has to offer as host Richard Knisely presents the work of local talent both in live performances and recent recordings produced by WGBH Radio. The live *Boston Symphony Orchestra* broadcasts (both

from Symphony Hall as well as from Tanglewood) and *MusicAmerica Presents Great Voices* join with *International Performances*, *A Note to You* and *NightAir* to round out a rich classical musical schedule. And, beginning in January, Ron Della Chiesa will begin his *MusicAmerica* broadcasts with a full hour of classical performances from this country's treasured classical-music legacy, making 89.7 the station to turn to for classical sounds from 7am until 2pm.

Notes Rivero, "Our engineering staff has always sought the best technology to faithfully represent the music being presented, and our producing staff has worked to set that presentation in a supportive broadcast context."

It's that on-the-spot ability to harness the best of audio and broadcast technology that has allowed WGBH Radio to excel in the area of live, in-studio performances on many of its classical programs. *Morning pro musica* has had a long history of live, in-studio performers on the program, and now, through *Off The Record*, WGBH Radio has increased the number of opportunities for local classical musicians to perform for a broadcast audience.

"I am particularly pleased that our newest projects are also continuing our tradition of offering an education in classical music programming," Rivero adds, noting how in-studio conversations with musicians and local between-performance features supplement many in-studio events as well as Boston Symphony Orchestra broadcasts.

"We're especially happy to be able to bring this classical exposure to young people," she concludes. "And as it piques the interest of longtime fans, we join these classical music lovers who are interested in opening this rich treasure chest of classical music to newer audience members who are finding it for the first time."

12:00 NightAir Music of the Cinema: Franz Waxman, Pt. II

10 Thursday

7:00 Morning pro musica Gistow: Paduana and Galliard; Holzbauer: Notturno #2 in E-flat ● Purcell: The Gordian Knot Untied; Jadin: Piano Sonata in f#, Op.4 #2 ● Pachelbel: Suite in B-flat; Mozart: Symphony #35 in D, K.385, "Haffner" ● Milhaud: La Cheminée du Roi René, Op.205; Suite for Wind Quintet; Beethoven: Piano Trio in B-flat, Op.1 #1 ● Berlioz: Benvenuto Cellini: overture, Op.23; Tansman: Sonatina for bassoon, piano; Vivanco: Karibe Taki; Villa-Lobos: Suite populaire brésilienne ● Pierné: Introduction and Variations sur une Ronde Populaire; Nielsen: Symphony #4

12:00 Off The Record 12th-20th c chamber music

1:00 MusicAmerica Swing Back to the 1940s: Ray Anthony's Orchestra; The BBC Big Band; Billy May's Orchestra. At 3pm, New York Cabaret Nights, Pt. VII, featuring Phyllis Newman and Maureen McGovern

7:00 Eric in the Evening Jazz

12:00 NightAir The Supremes' "I Hear A Symphony" opens a night of symphonies.

11 Friday

7:00 Morning pro musica Music from medieval Catalonia; Boyce: Voluntaries in D; Kuhlau: Divertissement in G; Soler: Quintet #4 in a for harpsichord, string quartet ● Selections from the Manuscript of Montserrat; Sor: Malbrough's en-va-t-en guerre; Rodrigo: Concierto de Aranjuez ● Ribas: "Pel teu amor"; Tarrega: Gran Jota de Concierto; Garreta: Suite in G ● Granados: Allegro de concierto; Milhaud: String Quartet #10, Op.218; Introduction and Allegro after Couperin's La Sultane, Op.220; Benguerel: Concerto for 2 flutes, strings ● Schickele Mix

12:00 Off The Record A *live* concert

1:00 MusicAmerica Presents: Great Voices In Celebration of Hispanic Heritage Month Placido Domingo and Jose Carreras in a program of songs and opera. At 2pm, Puccini's "Tosca" with Callas, Di Stefano and Gobbi

7:00 Celtic Sojourn

9:00 Blues After Hours At midnight, Blues Playback: The Blues, a Real Summit Meeting: Newport in New York (Pt. I)

Double Hit One Color

Overprint the same color to increase density.

Double cheeseburger, double fries, ten-gallon hat. Maybe the "more is better" theory came from the vastness of the American continent, with its room to roam and skies that feel too big for the landscape. Whatever the source, the idea seems to be particularly American. I feel strange suggesting that more costs less. In at least one instance though, I think the "more is better" approach makes good color sense.

Cost Comparison: 132% more than bench-mark, page 53.

Demo 2.3.1

Printing a double hit of one color (black) produces a darker color than possible with one pass.

BLACK

Rather than print two different ink colors as is normally done, two overlapping layers of the same color may be printed. This double hit of a single ink results in an unusually dense ink film, creating an exceptionally dense, rich color unobtainable by any other means. If you are careful, the impressive result may cost little more than a single color.

Offset inks generally are transparent, allowing light to pass through them and reflect off the paper surface beneath. Printing two passes of the same color makes two overlapping layers of the ink, reducing the amount of light normally reaching the paper. The result is an ink that is much denser and a color that is deeper and richer than is possible with a single layer.

Each printed ink color requires a film from which the printing plate is made. A one-color job requires one film; a two-color job two films and so on. Since each film costs something to produce, you may save money if the same film is duplicated and used for both passes of the color. However, registration of two identical films and ink layers is difficult. Small reversed areas will become a problem, but it can easily be fixed using traditional trapping techniques.

I think the double-hit technique is ideal for very large areas of solid ink coverage. I used it to get very dark color, black over black for example. The result, especially if the black ink is matte on white gloss paper, is a black so deep that it looks like a black hole. Two halftones of the same photo may be superimposed if screen angles and tonal densities are adjusted appropriately. This adds richness and depth to photos that have large dark areas.

Conversely, a double hit is also used to make very light color. It's common to see a double hit of opaque white on a dark-colored, uncoated paper. This is usually done to provide a white area for the printing of four-color process on the dark paper.

I've also seen the use of two different films, with different design elements on them, for two hits of the same color. There is no significant cost savings with this, but it opens up more creative potential for dramatic expression and communication.

Dense, rich ink color produced by overprinting two passes of the same color is shown off best by contrast. Juxtapositions of single and double layers of the color cause the dense, double layer to look darker by comparison. This double hit requires the creation of two different plates.

Take advantage of the extra density of this technique by contrasting small reverse areas of bright white paper in the midst of your largest dark area. (See Technique 1.1 Reverse Areas.)

If the size and shape of my job allows, I consider cropping, shifting or rotating one of two identical films. This eliminates trapping and dot-matching difficulties and can result in some spectacular and inexpensive special effects.

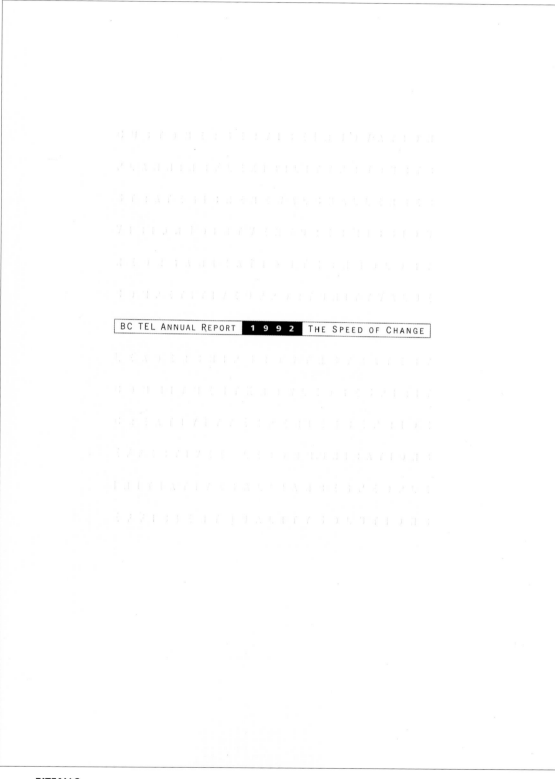

BC TEL ANNUAL REPORT **1992** THE SPEED OF CHANGE

2.3.1

A Design
Collaborative

BC Tel Annual Report,
8.5" x 11".
Double hit of black on
the front cover makes a
dramatic contrast with
subtle typographic
emboss. Notice how the
reversed type "1992" is
bold to avoid registra-
tion problems.

PITFALLS:

Halftones are a real problem in this technique. It is virtually impossible to overprint two halftone images created from the same film precisely enough to keep them looking sharp. The dot-for-dot registration required is asking for trouble.

Duotones

Print photos in two colors for extended tonal range.

I enjoy movies. But when the matinee is over, I always seem to forget myself and walk out the exit unprepared for the bright sunlight. The minutes of blinking and squinting are a painful but beautiful reminder of the sensitivity of the human eye. And my sensitive eyes are a reminder of an important use of two colors.

Human eyes respond to a world of subtle variations of value and hue. Often, single-color photos seem flat when they are printed, lacking warmth and believability. A photo printed in two colors, a duotone, adds an extra dimension of believability and expressive value at a reasonable cost.

Demo 2.4.1

This duotone image is made of black and brown. The black halftone is normal gray scale, precisely reproducing the values from the original continuous tone photograph. The brown halftone has a 5-10% darker value in the light to medium areas of the original and a 10% lighter value in the darkest areas of the original.

Notice how the increased value of the brown in the light to medium areas gives the concrete a warm tone.

BLACK

BROWN

The eye can discern many more shades of gray than can be printed using conventional halftone methods. Superimposing two halftone representations of the same image, each a different color, each carrying a different tonal range, produces many more values than is possible with a single color. The resulting duotone will appear richer and more life-like than a single-color halftone.

Duotones are typically printed with gray and black inks. The tonal range of the black is shortened so that it carries dots primarily in midtones and shadow areas. The tonal range of the gray ink carries detail primarily in middle tones and highlights. Of course, a duotone may comprise any two colors, but the darker hue generally carries shadows and the lighter hue carries midtones and highlights.

Duotones are complex. The skill and technical precision required to create a successful duotone are complex and not inexpensive. Consequently, duotones are neither easy to envision nor specify. It is difficult to precisely specify the desired tonal range for each halftone color in a duotone. It is difficult to know what to ask for, or even what terms to use. That is because terms to facilitate communication between designer and printer are vague: midtone, highlight, quartertone. Clearly illustrated examples of specific results are also rare. However, there are a few tools to help sort through the mess. These tools illustrate different duotones and explain how to specify them.

DuPont's SpectraTone is a system which includes a book of examples identified by code number. However, some imagination may be required to find a two-color situation that approximates the specific one you envision.

I've used desktop software programs such as Photoshop to facilitate duotone creation, dramatically reducing cost. Photoshop not only demonstrates what a specific duotone will look like but generates final film files for the duotone as well. Halftone tonal ranges are controlled for each color and the effect is shown on screen. When the desired effect is achieved, the file is output to a high resolution imagesetter for eventual offset

printing. The cost is minimal since the source can be a simple black-and-white scan.

I've also used an even simpler but less sophisticated method to generate duotones. I've mechanically superimposed two copies of the same halftone photo. Many software programs will allow the overprinting of two copies of the same image in different colors. This do-it-yourself duotone requires some skill with screen angles and registration, but it is impressive for the cost. The last time I did it, I made one halftone photo using traditional round dots and the second halftone using very high-resolution pixel bitmap. It sure helped some soft-focus antique photos. The result was much more exciting than a typical photo.

Although technically it is not a duotone, I've printed a conventional black halftone over a flat screen tint of a second color of the same size making a duotone-like effect. This fake or flat tint duotone is easy to make, impressive and cheap.

Successful duotones require thought about the value of hues. A clear value difference is helpful. One hue is typically dark, the other mid to light in value. Remember that some hues are naturally dark in value (blue is an example), while some are light, yellow being the lightest. It just is not possible to have a dark yellow, not without adding something to darken it.

The reference of hues to natural objects is a second sense in which a successful duotone requires careful color selection. I avoid black and blue duotones of human subjects. They create the appearance of a cadaver, probably not a good idea in a hospital brochure for example. A little thought about local color, the color objects appear in nature, helps me avoid embarrassing duotone mistakes. **Be careful with duotones on uncoated paper. Dot gain may require a substantial reduction in the density of midtone and shadow areas.**

BLACK

BROWN

Demo 2.4.2

This fake or flat tint duotone image is made of black and brown. The black halftone is normal gray scale, precisely reproducing the values from the original continuous tone photograph. A rectangular tint of the light brown, the same size and shape as the halftone, is printed behind it.

Notice how the overall tint of the brown adds warmth to the concrete. Since the brown tint is the same value behind the entire image, it makes the white arrow light brown. This flattens the overall tonal range, a necessary trade-off in fake duotone images.

Tonal range of halftones, highlight - midtone - shadow

Frequency of halftone screen, dpi

Type of halftone screen, dot - line

Hues of inks, primary - neighbor - opposite

Values of inks, dark - light

Intensity of inks, intense - subdued

2.4.1

Clifford Stoltze
Design

SEGD cover, 11" x 17".
Red/green duotone in
the center contrasts
nicely with red halftone
at top and green
halftone at bottom.
Printed on newsprint,
this is a clear demon-
stration that duotones
don't need to be
restricted to expensive
projects printed on fine
paper.

A QUARTERLY PUBLICATION OF THE SOCIETY FOR ENVIRONMENTAL GRAPHIC DESIGN

Winter 92
Volume 5
Number 4

Message(s)egd

SOCIAL RESPONSIBILITY
in environmental graphic design

THING THING RIGHT THE

displacement

revolution

This exhibition will show winning works from a national competition, sponsored by 2AES, open to architectural students on the graduate and undergraduate levels in the United States. A jury of noted architects will determine the works to be displayed. This exhibition will provide a rare opportunity for talented students to exhibit work outside of the academic venues normally available, thus exposing the student to a wider audience. It will also enable those outside of academic spheres to sample some of the best work being produced currently by students.

2.4.2

Tenazas Design

CfCA poster, 18" x 25".
Gray/black duotone
enriches the tonal
range and color of the
photo.

CfCA 2AES

Center for Critical Architecture/2AES
is a San Francisco non-profit organization
founded in 1987. By exhibiting new and
experimental works, 2AES provides the
design community with a forum for the
discussion of alternative ideas in art and
architecture, stimulating a dialogue and
fostering a critical community among both
professionals and the general public. The
model and inspiration of this endeavor is
the Storefront for Art & Architecture in
New York City.

Exhibition
August 24 – October 1, 1993

CfCA/2AES
Center for Critical Architecture/2AES
1700 17th Street
Second Floor
San Francisco, CA 94103
415.863.1502

Entry Fee: $35

Deadline: June 25, 1993 postmarked

repl cem nt

I'd like to know more about these Atex products

☐ Deadline
☐ Enterprise
☐ Press2Go for Editorial
☐ Press2Go for Advertising
☐ Reflex
☐ Communications Manager

☐ EdPage, Image Services & FPO
☐ Architect, ClassPage & Display
 Ad Services
☐ WorkGroup Publishing
☐ Fault Tolerant File System
☐ Gateway

**I'd be interested in reading about the following technol-
ogy, software, prepress or industry trends in upcoming
issues of *Atex Connections*.**

Name

Name of Organization

Address

2.4.3

Sametz
Blackstone
Associates, Inc.

Atex reply card,
3.5" x 6".
Solid yellow-green
forms the background
for a conventional black
halftone creating a duo-
tone effect without the
expense of two half-
tone films.

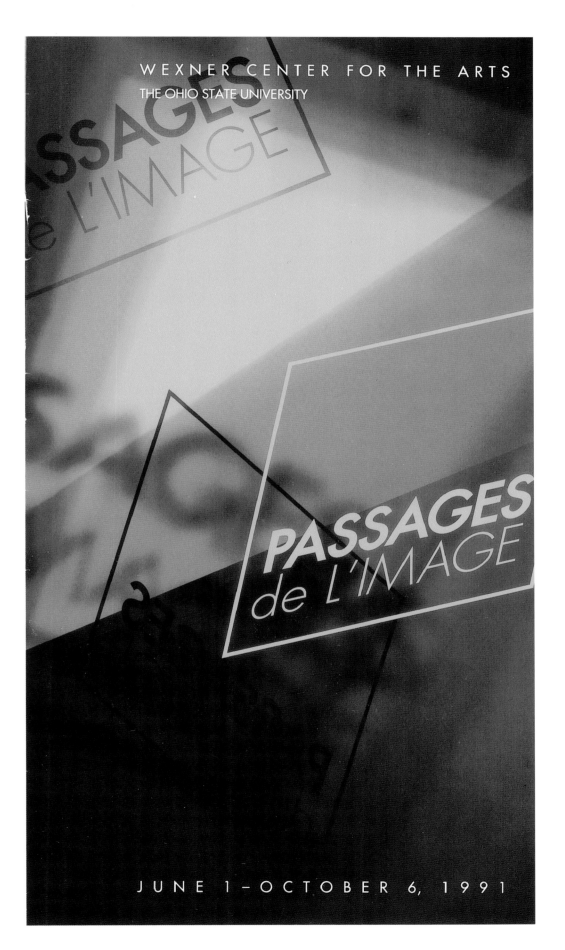

WEXNER CENTER FOR THE ARTS
THE OHIO STATE UNIVERSITY

PASSAGES
de L'IMAGE

JUNE 1 – OCTOBER 6, 1991

2.4.4

Wexner Center
Design

Program, 6.5" x 12".
Solid blue-green forms
the background for a
conventional black
halftone creating a duo-
tone effect without the
expense of two halftone
films. Small reverse
white type at bottom
adds a third color, that
of the paper.

2.4.5

Nancy Skolos,
Skolos/Wedell,
Inc.

Lyceum poster series.
Duotone photo images
unify a series of
posters. In each poster,
near complementary
colors blend to form a
gray or muted brown.
The muted color allows
the two brighter colors
to stand out through
enhanced intensity. In
each case the unmuted
color is used to make
key copy elements
stand out.

2.4.6

Nancy Skolos,
Skolos/Wedell,
Inc.

2.4.7

Nancy Skolos,
Skolos/Wedell,
Inc.

A
TRAVELING
FELLOWSHIP IN
ARCHITECTURE

offered to undergraduate
students from invited
schools who have
completed five
semesters of
study.

invited schools:

Southern California Institute of Architecture
Rensselaer Polytechnic Institute
The Boston Architectural Center
Moscow Architectural Institute
University of Cincinnati
Washington University
McGill University

an internationally recognized SCHOOL OF MUSIC located in
the Mississippi Delta—the cradle of America's
first authentic music

the blues

LYCEUM

competition

1st prize: $7,000 for
six months
travel abroad

2nd prize:
$4,000 for
three months
travel abroad

3rd prize:
$1,000
grant

Alternate
Citation

the jury will be held on
at McGill April 7-9 1993
in Montreal, Quebec Canada
Followed by a public
forum and announcement
of the winners.

1993 JURY

chairman
Samuel
Mockbee
F.A.I.A.
Mockbee/Coker
Architects

Trevor Boddy
Professor of
Architecture
Carlton
University

Andrea Leers
F.A.I.A.
Leers Weinzapfel
Associates

Randall Morton
Associate
Ehrenkranz &
Eckstut Architects

Mark Fischer
AIA
Lyceum Fellowship
Committee

93

LYCEUM
FELLOWSHIP
COMMITTEE:

JON McKEE,
CHAIRMAN
AND
FOUNDER

MARK A.
MUTKEN

PETER
VINCENT

JOSEPH
GZIABOWSKI

1000
Massachusetts
Avenue
Cambridge
Massachusetts
02138

2.4.8

Nancy Skolos,
Skolos/Wedell,
Inc.

3.

Three-or-More-Color Techniques

Access to three or more colors opens up the full range of color options. This section explains various techniques that will maximize the impact of three or more colors without breaking your budget.

The cost of your three-color or four-color printing will depend on what kind of press you're using, how you produce the art and whether you use four-color photos. This chapter offers techniques that can reduce the cost of multiple-color jobs by as much as half.

The staggering potential color variety of three- and four-color is worth the extra cost and effort. Some of the options are outlined in the matrix on the next page. There is certainly a cure here for nearly any color headache.

All cost comparisons are based on the cost of printing a benchmark project: 5,000 pages, 8.5 x 11", black ink on both sides, 70# white offset paper. The benchmark represents the lowest possible printing cost. All comparisons are approximations. Contact your printer for a more precise estimate on your project.

The three-color matrix adds five new techniques to the two-color matrix, for a total of eighteen options.

Notice that each three-or-more-color option has multiple variable choices, one for each color, multiplying the number of choices to a staggering level.

Variables

Size	Large - Small
Quantity	Few - Many
Value	Dark - Light
Hue	R O Y G B V
Intensity	Dull - Bright

	Size Large.....Small	Quantity Few.......Many	Value Dark........Light	Hue Red.Or.Yel.Gr.Bl.Violet	Intensity Muted.....Bright
Reverse					
Halftone Tint					
Blended Fountain					
Color Paper					
Change Ink					
Change Backup					
PrePrint Imprint					
Special Inks					
Other					
Two Like Three					
Mix Tints					
Double Hit					
Doutone					
Tritone					
Process					
Substitute Process					
Other					

Three or More Match Colors and Tints

Cost Comparison 165-215% more t benchmark, page

Mix three color screen tints to make additional colors.

Two's company. Three's a crowd. This old cliché, which I aimed at a little brother years ago when I was dating my wife, also applies to two and three colors. If the tints of two colors make good company, then the tints of three make a population explosion of color.

The magic of halftone tints and their mixtures is a rich source of color variety (see Technique 2.2 Two-Color Halftone Tints). Simple color math shows the superiority of three match color tints over two: Ten tints each of two colors result in a hundred possible tint combinations; ten tints each of three colors yields a thousand. That is a lot of bang for one additional color.

The halftone tints of three different ink hues may be combined to create new hues. Combination of any tint percentage is possible, 1% green plus 87% yellow for example. A combination of tints of one, two or all three hues is possible. As always, moiré caused when combining halftone screens needs to be minimized by adjusting screen angles. Even optimal screen angles can never totally eliminate moiré texture, but careful color specification by the designer will minimize it. Moiré will be most obvious in combinations with similar percent values of each color: 35% green, 35% gray and 30% black for example. Using decisively unequal tint percentages will help alleviate the problem. Printing one of the colors at 100%, no halftone dot, will help even more, since one screen angle problem has been completely eliminated by the solid.

Knowing about a project's production can do more than just avoid moiré problems, it can sometimes add a free color. For example, three-unit presses are uncommon. Checking with the printer may reveal that a three-color job will ultimately run on a four-unit press. If so, it will cost little to go ahead and add a fourth color or a varnish, allowing even greater opportunity for creativity.

Like two-color combinations, three-color screen tint combinations are specified to the printer by marking the percentage of each color on the final art. However, anticipating what color the specified combination will make is even more difficult with three colors than with two. Many of the reference materials used to guide color choice rely on acetate overlays to explore tint combinations. These acetates and the inks on them are not as transparent as printing inks themselves, so the results are inaccurate. To overcome this problem, there are three-color specifiers which show actual printed combinations of match ink colors. Pantone makes a nice one. Eight tint percentages of three match colors are shown on each page. But even this illustrates only a very limited number of possible color combinations. Some imagination will be required to find a three-color situation that approximates the specific one envisioned. The best way to determine the result of any specific color combination is to test it. A simple demonstration similar to the Pantone specifier can be constructed and

GREEN

RED

YELLOW

Demo 3.1.1

Printing ten tints each of three colors (green, red and yellow) produces a thousand distinct colors. Only one hundred are shown here.

proofed using typical proofing materials for about $120. Or if the project is a large press run, the printer may do a press proof free.

Three-color screen tints may also be specified on the computer with appropriate software commands. Again, take care when you do it yourself to confirm that the screen angles are optimized.

I like overlapping different screen types, such as dot and line. It's a creative way to avoid moiré. Or, for screens of the same type, I'll specify halftone tints in drastically different screen frequencies, a 30-line over a 120-line screen for example, avoiding moiré and creating a striking tint effect.

The hues selected determine the nature and variety of hues that result from their mixtures (see Technique 2.2 Two-Color Halftone Tints). Near neighbors on the color spectrum will produce less variety, opposites and primaries more. Similarly, combining hues that are medium to light in value creates greater diversity than combining hues of extremely dark values. Very dark value inks tend to have gray looking tints. The tint of a very dark green will be almost indistinguishable from a tint of a very dark blue. Again, blends and tonal progressions create the greatest possible variety of tint combinations.

I select a light value hue when I need to make a large tint area. Light hues, like yellow, make tints so clean that it is virtually impossible to see the dots, and my eyes are good! Light hues also reduce moiré problems when mixing with darker colors, for the same dot-disappearing reason. In general, the darker the color, the more obvious the halftone dot, the more prominent the moiré. Unless I want an obvious dot texture, I avoid large areas of black tints. They look coarse.

Avoid reversing fine lines and small type out of three screen tints. The chances of misregister and fill-in are great. Thin serifs on fonts like Bodoni are almost sure to disappear.

Sizes of tints, small - large
Quantity of tints, few - many
Value of tints, dark - light
 Frequency of halftone screen, dpi
 Type of halftone screen, dot - line
 Hues of inks, primary - neighbor - opposite
 Values of inks, dark - light
 Intensity of inks, intense - subdued

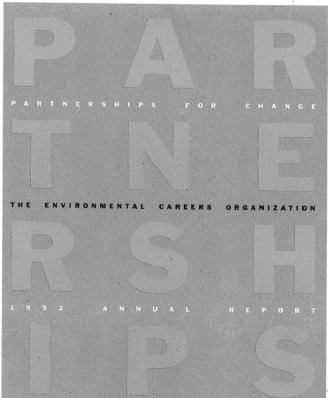

P A R T N E R S H I P S

PARTNERSHIPS FOR CHANGE

THE ENVIRONMENTAL CAREERS ORGANIZATION

1992 ANNUAL REPORT

3.1.1

Sametz Blackstone Associates, Inc.

Environmental Careers Organization annual report, 8.5" x 11". Solid coverage of three match colors, green, brown and black, gives a rich, earthy quality appropriate for the subject. Notice how the white type adds a fourth color, that of the paper.

3.1.2

Sametz
Blackstone
Associates, Inc.

Pension Reserves
Investment Trust Fund
annual report,
7.25" x 11".
Four match colors,
peach, purple, black,
and green, enrich a bar
graph.

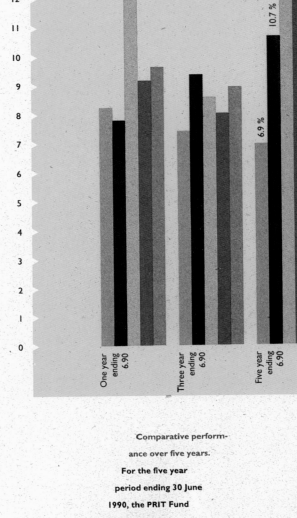

% 13
12
11
10
9
8
7
6
5
4
3
2
1
0

15.8 %
14.2 %
12.8 %
10.7 %
6.9 %

One year ending 6.90

Three year ending 6.90

Five year ending 6.90

◄ 90 Day Treasury Bill

◄ Shearson Lehman Aggregate

◄ SAF S&P

◄ PRIT

◄ Public Fund Average
Source: National Association of State Investment Officers

Comparative perform-
ance over five years.
For the five year
period ending 30 June
1990, the PRIT Fund
has an annualized
return of 14.2%,
placing it in the top
decile of public funds
nationally.

4 /

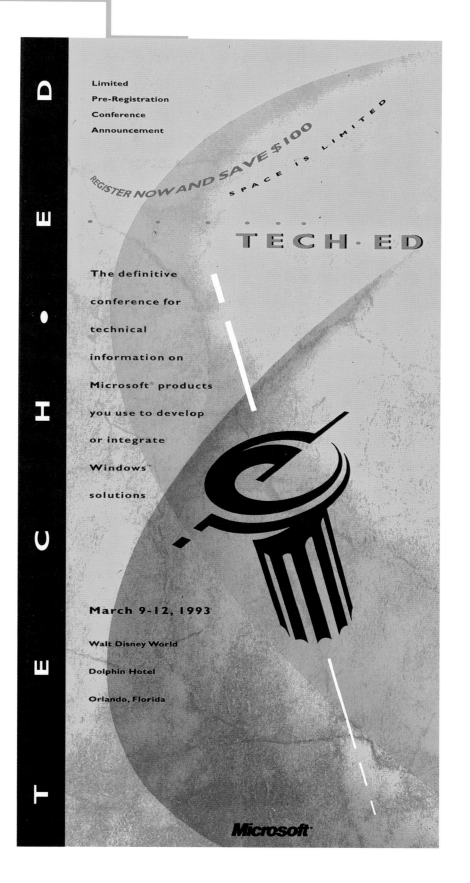

3.1.3

Hornall Anderson
Design Works,
Inc.

TECH ED brochure,
5.5" x 11".
Blends make the most
of four match colors:
black, purple, yellow,
and green.

Print photos in three colors for additional color subtlety.

I love the soft, lavender-gray clouds of evening brushed with just a tinge of orange. It's the beauty of subtle variations in hue and value that make our color environment so rich. Richness and subtlety on a budget is the goal of the tritone.

Because the created world around us is so rich in color, printed images often seem uninterestingly flat. A photo printed with three colors of ink, a tritone, adds a wealth of subtle color sophistication and interest without the expense of four-color separation.

Superimposing three halftone representations of the same image, printed in three different match colors, creates a tritone. The source is usually a single black-and-white photo. Each halftone of the photo carries a different tonal range which, when combined, produce a range of values and hues that can rival that of a full-color separation. All of the typical concerns regarding screen angle and moiré that apply to screen tints and duotones apply to the tritone as well (see Technique 3.1 Three or More Match Colors and Tints).

Tritone images are neither easy to make nor inexpensive. And even more than duotones, tritones are difficult to envision and to specify. Lack of precise terminology to facilitate communication between designer and printer makes it difficult to specify the desired tonal range for each halftone color. Making matters worse, well-defined examples that illustrate the result of a specified tritone are rare. This makes it hard to see what is wanted and communicate it to clients and printers. As in duotones, there are a few tools to aid in tritone specification. These tools illustrate results and describe how to achieve them. For example, DuPont's SpectraTone is a system including a book of examples identified by code number for communicating with prepress suppliers. As in three-color tints, some imagination will be required to find a three-color tritone situation that approximates the specific one envisioned.

Tritones are powerful but not without cost. As the cost of color separation declines with advances in technology — desktop scanners and photo CD are recent examples — the cost difference between full-color and tritone images should diminish. At the same time, desktop process color makes process color tritones easier to envision and less expensive to do.

Desktop software programs like Photoshop are an inexpensive alternative means of not only envisioning how a specific tritone will look, but generating final film for it as well. Halftone tonal ranges are controlled for each color and the effect is shown on screen. When the desired effect is achieved, the file can be output to a color printer or high-resolution imagesetter for eventual offset printing. The cost is low, about $60 for film and $60 for a proof, since the source can be a simple black-and-white desktop scan.

Cost Comparison: 159-200% more than benchmark, page 97.

BLACK

BROWN

BLUE

Demo 3.2.1

This tritone image is made of black, gray and blue. The black halftone is normal gray scale, precisely reproducing the values from the original continuous tone photograph. The gray halftone has a 5-10% darker value in the light to medium areas of the original. The blue halftone has 5-7% darker value in the lightest areas, 10-30% lighter value in the medium areas and 20% lighter value in the darkest areas of the original.

Notice how the increased value of the brown in the light to medium areas gives the concrete a warm tone, while the dramatic increase of blue in the lightest areas gives the arrow a blue cast.

In the past I have considered tritones as an option only when I had photo images included with a job that called for three match colors. If I had three colors anyway it made sense to enrich the photos by making them tritones. Now, since Photoshop makes tritones less expensive and easier to envision, I intend to use them more often.

Successful tritones require thought about the selection of hues. Hues will mix to form new hues in the tritone. Select hues that will combine to form an overall hue that is appropriate. Yellows, reds and blacks result in sepia tritones. The effect is that of old photos.

There is a second sense in which a successful tritone requires careful hue selection, the reference of hues to natural objects. An overall blue tritone is unappealing for a human face but may be beautiful for water or grapes. A little thought about local color, the color objects appear in nature, will help avoid an embarrassing tritone mistake.

I add another level of complexity to tritone images by making one of the inks a metallic. It will cover transparent ink dots because it is so opaque. Results depend on the ink sequence, whether the metallic goes down first, middle or last, but the effect can be striking.

RAISING THE ROOF
OPENING DOORS

Living Environments for People with AIDS

A NATIONAL DESIGN COMPETITION

BOSTON MASSACHUSETTS

Sponsored by
the City of Boston
Public Facilities Department
and the Boston
Society of Architects

Register by August 15, 1992

3.2.1

Clifford Stoltze
Design

AIDS poster, 17" x 24". Blending halftones of three colors, violet, purple and orange, creates a rich variety of hues. Notice the bright orange type in the center. The orange in the remainder of the poster is muted by adding the complement, blue-violet.

Tonal range of halftones, highlight - midtone - shadow

Frequency of halftone screen, dpi

Type of halftone screen, dot - line

Hues of inks, primary - neighbor - opposite

Values of inks, dark - light

Intensity of inks, intense - subdued

Desktop Process Color

Produce process color on the desktop for maximum color variety.

My dictionary defines "primary" as, "not derived from something else." Newton's prism exposed white light as a multicolored mystery, the full spectrum of color in an innocent beam of sunlight. From this primal power source comes the most powerful color cost-cutter of all.

Cost Comparison: 233% more than benchmark, page 97.

CYAN

MAGENTA

YELLOW

Color reproduction theory is founded on the ability of light's three secondary colors (the subtractive primaries), cyan, magenta and yellow, to mix and effectively reproduce nearly all of the colors in our experience. The ability of the halftone process to mix discrete quantities of color enables printers to create the illusion of full-color reproduction using only three inks (four, including black). Process colors are unchallenged in their ability to produce color variety.

Theory is fine but the real world doesn't always respect theory. Printing inks of three subtractive primaries should combine to make solid black, the opposite of white light. But they don't. Because of the transparency required for good color mixture, ink films of the primaries make not black but a nice, dark gray. So a fourth color, black, is printed with the primaries to add depth and richness. The four process colors therefore are cyan, magenta, yellow and black, CMYK.

Controlling the mixture of discrete halftone quantities of four colors requires sophisticated control. The expertise and technology required to control process color are not inexpensive. As with other techniques, screen angles and frequencies are critical factors. Unlike match colors, however, process color combinations are widely illustrated and relatively simple to specify. Predicting the hue that will result from a specific four-color tint combination is facilitated by color specification books where each process color is specified as a percent tint from 0–100%. Process color specifiers may be free from printers, or purchased from Pantone or other suppliers. The books show samples of thousands of process color combinations and identify their screen percentages. Because the system of process color is so well documented and illustrated, it is easy to understand and use. This makes it accessible to the nontechnical if they can gain control over technical processes.

Desktop computing is the technical key that makes process color cost-effective. Computer software makes it possible for designers to control process color. Process color tints may be specified and viewed on screen. When the desired hue is achieved, the file can be output to a color printer or high-resolution imagesetter for eventual offset printing. The cost is minimal since the output file simply consists of four films, already in register and ready to print.

Still, incorporating process color photos can be an expensive obstacle. Color photos require scanning, a procedure where a full-color original is optically broken down into the four process colors. Traditionally this has been expensive. It requires technical sophistication and equipment. But computer technology has brought inexpensive scanning to the desktop. While it is less accurate than traditional scanning, desktop scanning is easy and suitable for many applications.

Demo 3.3.1

Printing ten tints each of three process colors (cyan, magenta and yellow) produces a thousand distinct colors. Only one hundred are shown here.

Sizes of tints, small - large

Quantity of tints, few - many

Value of tints, dark - light

Frequency of halftone screen, dpi

Type of halftone screen, dot - line

I often use inexpensive desktop color scans as raw material, even for poster-size images. The blurred, pixelized effect can be quite beautiful and poetic. Placing it beside a high-resolution scan from a drum scanner can create a clear contrast statement.

I also rely on high-resolution scans as source material for complex composite images. I have a library of stock high-res scans, like cloud images, that I recycle for different projects. The only cost is a little planning and disks for archiving.

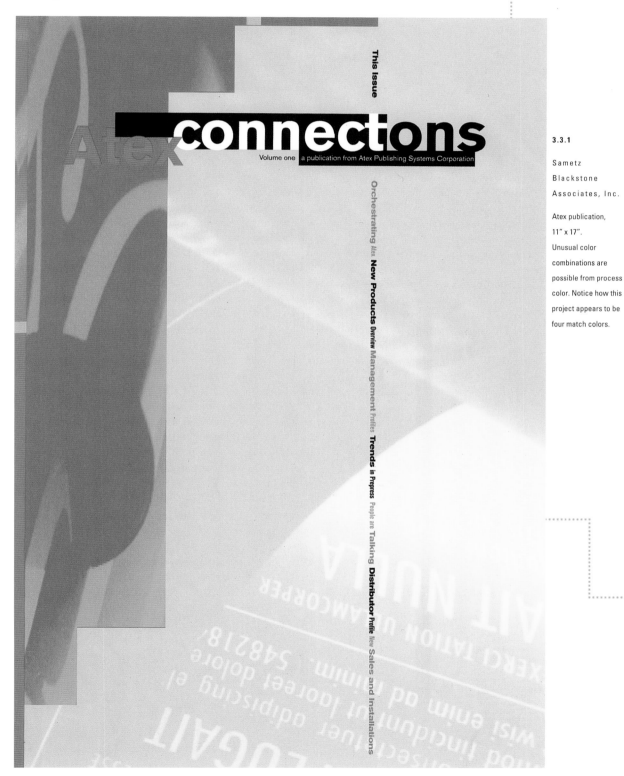

3.3.1

Sametz Blackstone Associates, Inc.

Atex publication, 11" x 17". Unusual color combinations are possible from process color. Notice how this project appears to be four match colors.

3.3.2

Mike Zender,
Zender +
Associates, Inc.

Percussion Group flyer.
7" x 10".
Inexpensive desktop
scans, blurred in scan-
ning and/or in
Photoshop, suggest
movement characteris-
tic of percussion
performances.

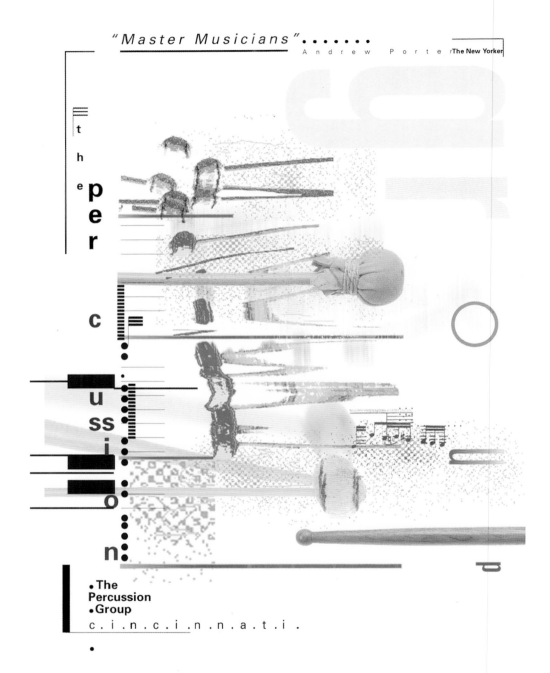

"*Master Musicians*" • • • • • •
A n d r e w P o r t e r **The New Yorker**

the

p
er
c
u
ss
i
o
n

• **The**
Percussion
• **Group**
c . i . n . c . i . n . n . a . t . i .
•

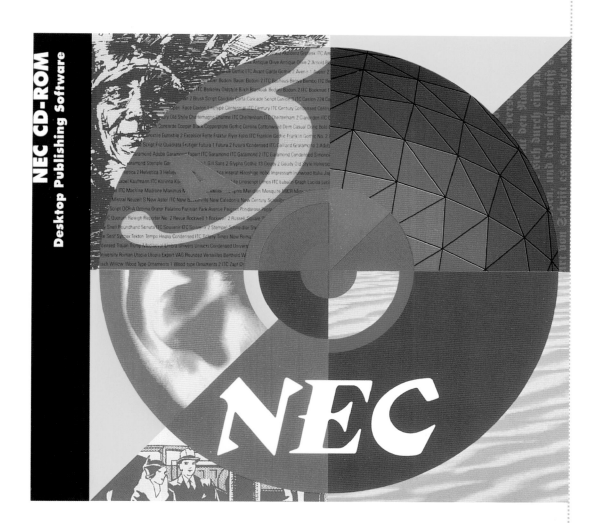

3.3.3

Liska and
Associates, Inc.
Designers

NEC booklet, 5.5" x 5".
Desktop process color
plus Day-Glo give a
feeling of excitement.

3.3.4

Mike Zender,
Zender +
Associates, Inc.

The Promise bulletin
insert, 5.5" x 8.5".
Desktop scans of
marble and cloud photo
from a previous project
merge in a computer
illustration.

THE
PROMISE...

THE
PROMISE
A CHRISTMAS MUSICAL

BASED ON THE MUSIC AND WRITINGS OF MICHAEL CARD

PRESENTED BY
FAITH
EVANGELICAL
FREE
CHURCH
5910 PRICE RD.
MILFORD, OHIO
831.3770

TICKETS MAY BE PURCHASED AT THE DOOR
SUGGESTED $3 DONATION
NON-RESERVED SEATING

B.C. A.D.

HIS
BIRTH
WOULD
CHANGE
ALL
TIME

PERFORMANCES:

DECEMBER 11 8 PM
DECEMBER 12 2 PM AND 8 PM
DECEMBER 13 7 PM
DECEMBER 14 7 PM

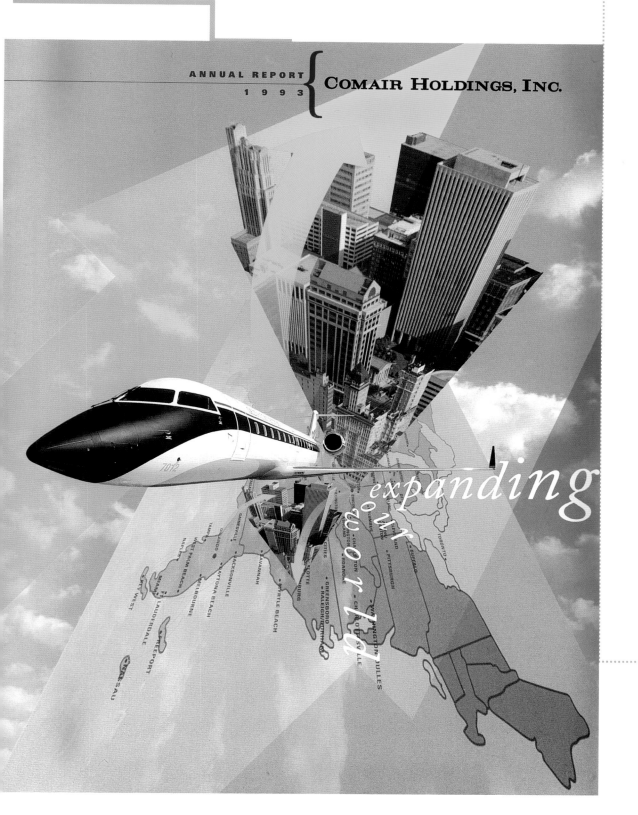

ANNUAL REPORT
1993 { COMAIR HOLDINGS, INC.

expanding our world

3.3.5

David Tong,
Zender +
Associates, Inc.

COMAIR annual report,
8.5" x 11".
High-resolution scans
are combined with
images from previous
Comair reports in a
theme of expansion.

3.3.6

A,B,C
David Tong,
Mike Zender,
Zender +
Associates, Inc.

Indiana Energy annual,
8.5" x 11", and quarter-
ly, 3.5" x 8", reports.
High-resolution scans
assembled on the desk-
top allow for striking
color variation at little
cost.

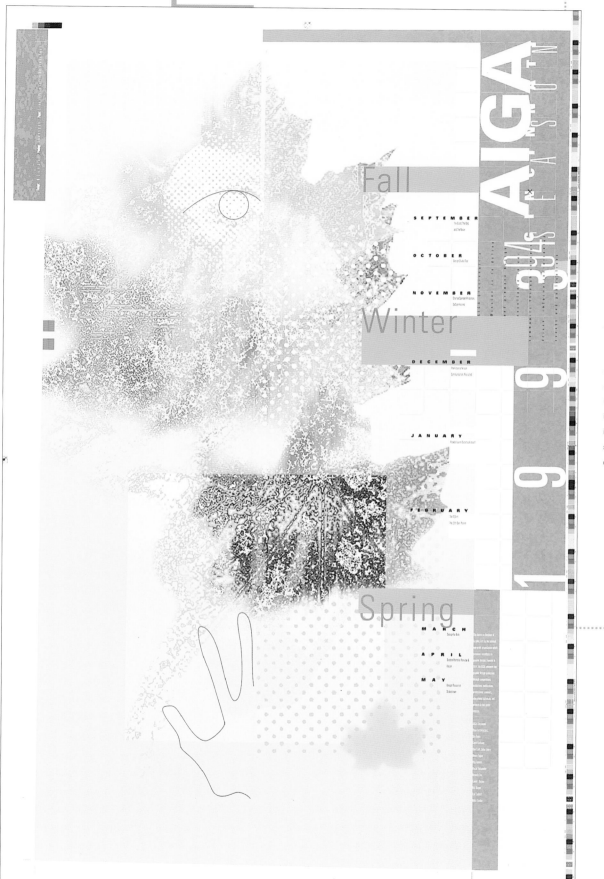

3.3.7

Mike Zender,
Zender +
Associates, Inc.

AIGA Cincinnati season
poster, 23" x 38".
Inexpensive desktop
scans of leaf photos
and actual leaves are
combined in a poster
illustration. Even large
images can be done
successfully on the
desktop.

3.4 Substitute Match Inks for Process Color

Replace a process with a match color for a surprising and inexpensive twist.

My wardrobe is limited. One of my favorite tricks is to buy a new accessory, a colored belt, sweater or tie, to give new life to an old outfit. Not only does slipping on a sweater totally change the look, but it often gets a second day out of a wrinkled shirt. Like changing cloths, exchanging process colors is an easy and cost-effective way to expand a process color palette.

Cost Comparison: 243% more than benchmark, page 97.

Process color uses mixtures of four colors to create the illusion of full color. But there is no reason why the four process colors must always be cyan, magenta, yellow and black. Substituting a match color for one or more of the process colors can add dramatic impact at no additional cost.

The four process color inks are carefully matched to industry standards to print realistic and predictable color. But four-color presses are simply four unit presses which lay down four different ink hues in a single pass. Normally the four colors are process colors, cyan, magenta, yellow and black. But there is no reason that a four-color press must print process color. It is possible for process color film to be prepared and on press use one of the four process color films to print a match rather than a process color. Deviations from the standard will make results difficult to predict but definitely different from the norm.

It is interesting to substitute metallic or fluorescent inks for one or more process inks. For example, print silver-gray in place of black. Be sure to consult with the printer when considering a process color swap, because metallic and fluorescent inks may have unusual properties requiring special consideration.

I have substituted silver for black in four-color photos. It was for a high-tech manufacturing project and added a machine-like quality to the photos. It was no trouble and no additional cost. Swapping silver for black or metallic gold for yellow gives a beautiful sheen and is fairly predictable. Exchanging fluorescent red for process magenta will give warmth and glow to a four-color subject.

Selecting hues that are close to the original process color in hue, value and intensity will produce the most predictable results.

Hues of inks, primary - neighbor - opposite

Values of inks, dark - light

Intensity of inks, intense - subdued

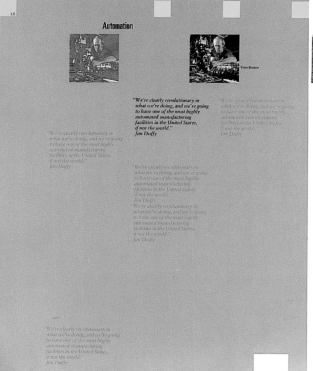

Automation

"We're clearly revolutionary in what we're doing, and we're going to have one of the most highly automated manufacturing facilities in the United States, if not the world."
Jim Duffy

Changing The Workplace

"We're clearly revolutionary in what we're doing, and we're going to have one of the most highly automated manufacturing facilities in the United States, if not the world."
Jim Duffy

"The new automation is going to broaden the skills of the people who work here."
Tom Slaughter

■ Tom Slaughter, manager of technical operations for future typewriters, doesn't hesitate when asked what effect the new automation will have on Lexington.

■ The new automation is going to broaden the skills of the people who work here," he says. "Employees are going to have much better understanding, knowledge, and ability in their work. There's going to be greater opportunity for people to expand what they do, and there's going to be more ownership in their jobs."

■ The good news is that a large portion of the new automation is here and operating. The better news is that it won't be long before the entire system is in place and operating.

■ The construction—the ripping out and tearing down of old equipment and machinery followed by the installation of the new automated equipment and machinery—should be finished by the end of next year.

■ Then, the seven automated manufacturing modules—keyboards, motors, cards, frame paperfeed and transport (FPT), covers, final assembly, and packaging—should be fully operational. About 150 IBM 7535 and 7540 Manufacturing Systems, instructed by 200 IBM Series 1s, 70 IBM Personal Computers, and three IBM 4341 Processors, will operate the modules.

■ "I can't say enough good about our new automated facility," says Jim Duffy, plant manager, future typewriters. "We're clearly revolutionary in what we're doing, and we're going to have one of the most highly automated manufacturing facilities in the United States, if not the world. With today's new product announcements, it's the biggest day in Lexington since the announcement of the SELECTRIC Typewriter."

■ The new automation had its beginning about four years ago, just about the same time the proposing and planning of the IBM SELECTRIC System/2000 Typewriters began.

■ The company took a hard look at the competitive world—and we've got a lot of competitors in the typewriter and printer business—in order to come up with a strategy to maintain our competitiveness in the marketplace," explains Ray Reichenbach, automation manager, future typewriters. "The answer was to control our costs, while maintaining our quality. Further study showed that new automation would reduce cost while actually improving quality, and therefore help us maintain our competitiveness."

■ It was not cost effective to change current Lexington products, but the IBM SELECTRIC System/2000 Typewriters were designed for automation.

■ A group that grew to over 200 employees—including electrical, mechanical, industrial, automation, and manufacturing engineers, as well as computer programmers, systems analysts, and machine tool designers—went to work designing the equipment and machinery for the individual modules.

■ At the same time, a group of facilities engineers went to work planning the space and support needed for the new automation. Their job was equally difficult because they had to maintain the current products manufacturing lines while making room for the new automation.

■ "It took a lot of hard work," says Ed Durbeck, manager of site services. "And it took a tremendous amount of cooperation between maintenance, manufacturing, facilities and all the related support groups.

■ The automation required some large changes. For example, the entire roof structure of the west side of Building 002 had to be strengthened so it would support four miles of new conveyor systems for the automation."

■ In all, facilities planned, shifted and used over a million square feet of manufacturing space in making room for the automation. They also added eight electric substations to meet the increased need for power.

3.4.1

Zender + Associates, Inc.

IBM brochure, 9" x 12". One scanned image is repeated several times; all but one image has had the black plate replaced by silver to create a high-tech look.

3.5 Other Multicolor Processes

Use other production methods and materials to add creative impact

Icing is my favorite part of the cake. It is the last thing that goes on the cake, but it adds the greatest flavor, variety and beauty. The same is often true in producing printed communication. The last step in the process can be the best.

Any printed piece undergoes a succession of processes on the way to delivery. Some involve cutting, trimming, folding and binding. Others involve packaging and assembling. Any additional process becomes an opportunity to the color savvy. With planning and imagination a required step can become the icing on the cake.

Cost Comparison: the processes vary so greatly that a general cost comparison is not possible

Offset printing has been the focus of this book. But there are a number of other means of printing color pages which can be quite economical. Color thermal, ink jet and color copiers print beautiful color pages at relatively low cost in very limited quantities. These processes convert data from a computer via a Raster Image Processor (RIP) into color images on paper or film. One or many copies can be printed from a file taking from several seconds to several minutes per page.

Stickers may seem childish, but they can be an economical way to add color to a printed piece. Single or multiple-color stickers can be printed in bulk at low unit cost, then added to a variety of printed pieces for a spot of color. Preprinted single-color stickers are available to add spice to any project. One of the least noticed of stickers, not cheap but required, is the postage stamp. It can add just the right spot of color if you are careful.

When printing two sides of a sheet, printing a different number of colors on opposite sides of the paper can trim cost. Printing two, three or four colors on one side and one or two on the other can add a lot of impact while keeping down cost.

If the project is a book with signatures, planning the distribution of multiple-color signatures among single-color signatures can extend color impact and make the most of multiple-color cost. It may even be possible to gang widely distributed color pages onto one press sheet if the binding method will allow.

As mentioned in Technique 1.4 Paper Change, binding methods such as spiral and wire-o can provide opportunities for additional color impact. The color of the binding material itself can add color accent to every page, as can ribbons, dust jackets and fly sheets.

Trimming or die-cutting a sheet offers a final opportunity to add impact to a project. An unusual cut, fold or score will attract attention, and the shadows may be strategically utilized to actually affect color value.

3.5.1

KODE Associates
Inc.

LinoGraphics encore
stickers. Stickers are an
inexpensive way to add
color to nearly anything.

3.5.2 A & B

David Tong,
Zender +
Associates, Inc.

C&W parts catalogs,
8.5" x 11".
Reprinted three-color
catalog, using slightly
altered film and a new
color palette, gives con-
sistency yet clearly dis-
tinguishes one
edition/year
from another.

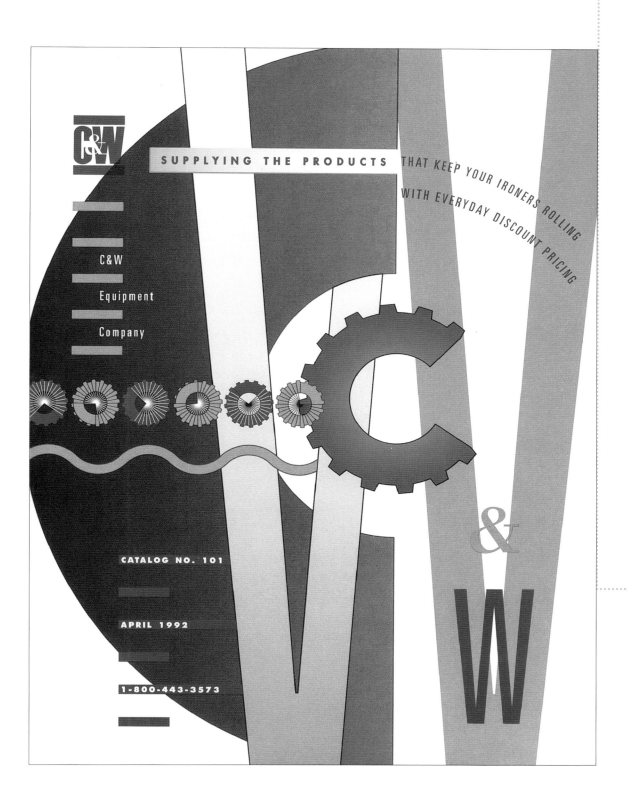

SUPPLYING THE PRODUCTS THAT KEEP YOUR IRONERS ROLLING WITH EVERYDAY DISCOUNT PRICING

C&W

C&W
Equipment
Company

CATALOG NO. 101

APRIL 1992

1-800-443-3573

3.5.3 A & B

KODE Associates
Inc.

LinoGraphics flyers,
8.5" x 11".
Final printed output on a
color copier is an eco-
nomical solution when
the print run is short.
This allows for design
variety with message
consistency. Notice the
same pricing block on
both flyers.

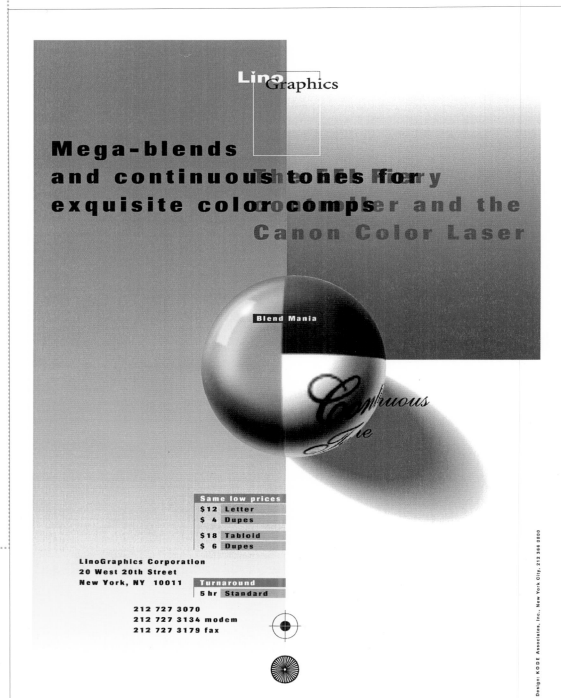

Lino Graphics

**Mega-blends
and continuous tones for
exquisite color comps** and the
Canon Color Laser

Blend Mania

Continuous
Tone

Same low prices	
$12	Letter
$ 4	Dupes
$18	Tabloid
$ 6	Dupes

**LinoGraphics Corporation
20 West 20th Street
New York, NY 10011**

Turnaround	
5 hr	Standard

212 727 3070
212 727 3134 modem
212 727 3179 fax

Design: KODE Associates, Inc., New York City, 212 366 0800

LinoGraphics

visualize

pre-press

Continuous tones for realistic color compositions

Introducing **The EFI Fiery controller and the Canon Color Laser**

Same low prices	
$12	Letter
$ 4	Dupes
$18	Tabloid
$ 6	Dupes

LinoGraphics Corporation
20 West 20th Street
New York, NY 10011

Turnaround	
5 hr	Standard

212 727 3070
212 727 3134 modem
212 727 3179 fax

Design: KODE Associates, Inc., New York City, 212 366 0800

3.5.5 A, B, C,

KODE Associates
Inc.

KODE letterhead and
business card. Even let-
terhead system may be
printed on color copier,
allowing for design flex-
ibility and delicate
merging of typographic
and "typed" message
content.

20 west 20 street
suite 308
new york, ny 10011

212 366.0800
fax 366.0802

william
kochi

corporate communications
information design
graphic systems analysis

‹ODE

20 west 20 street
suite 308
new york, ny 10011

f a x 366.0802

212 | 366
0800

CORPORATE COMMUNICATIONS
INFORMATION DESIGN
GRAPHIC SYSTEMS ANALYSIS

‹
O
D
E

RECYCLABLE

3.5.6

KODE Associates
Inc.

3.5.7

Molly Schoenhoff,
Mike Zender,
Zender +
Associates, Inc.

Indiana Energy annual
report cover and
brochure, 8.5" x 11".
A gatefold annual
report cover doubles as
a brochure communi-
cating an environmental
theme. The result was
an overall shorter print
run for the annual, sav-
ing cost and paper.

Indiana Energy, Inc.

*You see the outline of the city ahead. It looks a little cloudy —
or is it? On closer examination you realize those aren't clouds hanging over your community —
it's pollution. Pollution from cars, trucks and buses, from industrial processes, from everyday
activities. And you're not alone. Nearly every major city or metropolitan area in the
United States has unhealthy levels of air pollution that exceed standards mandated by the
U.S. Environmental Protection Agency.*

*There are many possible solutions to our growing pollution problems.
One partial solution is already available and affordable — it's natural gas.*

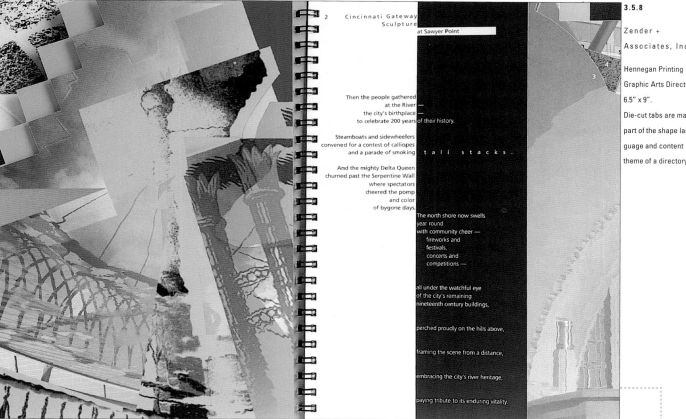

2 Cincinnati Gateway
 Sculpture
 at Sawyer Point

Then the people gathered
 at the River —
 the city's birthplace —
to celebrate 200 years of their history.

Steamboats and sidewheelers
convened for a contest of calliopes
and a parade of smoking t a l l s t a c k s .

And the mighty Delta Queen
churned past the Serpentine Wall
 where spectators
 cheered the pomp
 and color
 of bygone days.

The north shore now swells
year round
with community cheer —
 fireworks and
 festivals,
 concerts and
 competitions —

all under the watchful eye
of the city's remaining
nineteenth century buildings,

perched proudly on the hills above,

framing the scene from a distance,

embracing the city's river heritage,

paying tribute to its enduring vitality.

3.5.8

Zender +
Associates, Inc.

Hennegan Printing
Graphic Arts Directory,
6.5" x 9".
Die-cut tabs are made
part of the shape lan-
guage and content
theme of a directory.

Combinations

"No man who values originality will ever be original. But try to tell the truth as you see it, try to do any bit of work as well as it can be done for the work's sake, and what men call originality will come unsought."
C. S. Lewis

I like ice cream. I like sundaes more. The mixture of flavors and textures is a multifaceted flavor bonanza. It illustrates the most dramatic color strategy of all, the multiplying effect of combining several techniques on one project. The result, as you will see, is magical.

The best technique to increase color isn't a technique at all. The greatest way to maximize color impact is to simultaneously use more than one technique at a time. It seldom costs any more to use several techniques at once, but it dramatically multiplies beauty and variety.

Real-life applications seldom use one technique only. Research for this book confirmed: It is hard to find examples that use just one technique. Most designs use some combination of techniques to maximize color impact. There is no reason why a large reverse area can't combine with screen tints and blended fountain, for example. It makes good economic sense and good aesthetic sense.

I don't choose techniques arbitrarily. My creativity flows out of the quest for an apt solution to a clear problem. I believe the best design results when the visual quality of the technique matches the concept and content of the communication. I can usually find several techniques that support what I'm communicating. It helps me to think of techniques in the form of a matrix. Visually arranging all the possibilities stimulates my thinking, challenges my normal way of doing things, and helps me think of new possibilities.

I seldom eat one item at a time. I think plain steamed rice is boring. That's an aesthetic confirmation for mixing techniques judiciously. A large reverse area maximizes the gradual color change of a blended fountain. The large area gives room for the beauty of the blend to shine. Experience and observation will give insight on how one technique will influence another. Studying the examples that follow is a good place to start.

The two-color matrix adds four new techniques to the one-color matrix, for a total of thirteen options. Notice that each two-color option has two variable choices, one for each color, dramatically multiplying the number of choices.

Variables

Size	Large - Small
Quantity	Few - Many
Value	Dark - Light
Hue	R O Y G B V
Intensity	Dull - Bright

Reverse
Halftone Tint
Blended Fountain
Color Paper
Change Ink
Change Backup
PrePrint Imprint
Special Inks
Other
Two Like Three
Mix Tints
Double Hit
Doutone
Tritone
Process
Substitute Process
Other

Column headers (repeated): Size (Large — Small), Quantity (Few — Many), Value (Dark — Light), Hue (Red · Or · Yel · Gr · Bl · Violet), Intensity (Muted — Bright)

4.1

Zender +
Associates, Inc.

WGUC radio station
poster, 23" x 35".
The ten-color blended
fountain (1.3) in the cen-
ter is combined with
four match colors to
create a poster with
color suitable for any
decor. A total of four-
teen ink colors on a six-
color press in one
press run.

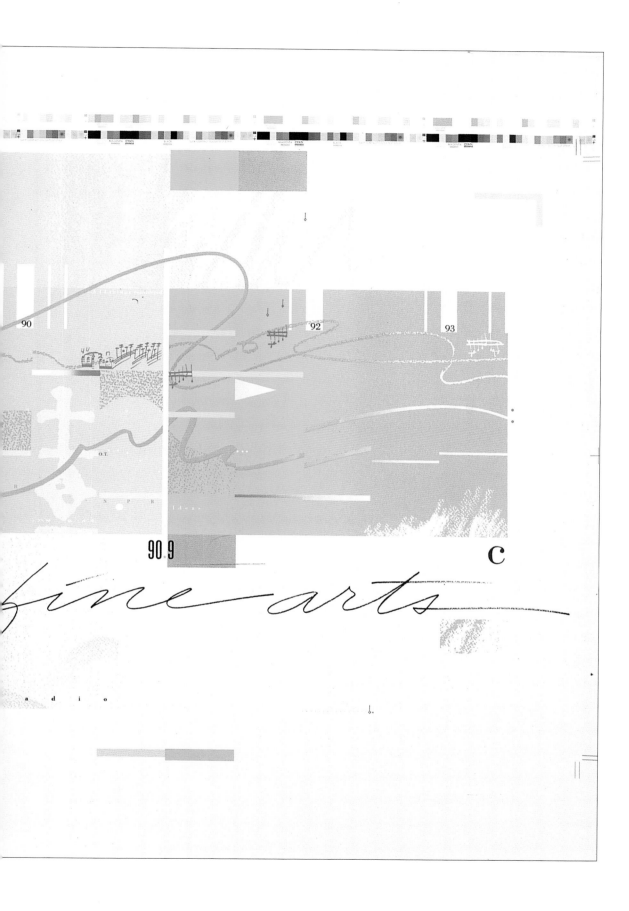

90 92 93

90.9 C

fine arts

radio

4.2

Hornall Anderson
Design Works,
Inc.

The Center for Oral and
Maxillofacial Surgery
brochure, 5.5" x 12".
Blended fountain (1.3)
with white reverse (1.1)
and gray overprinting
creates rich color vari-
ety from two-
color printing.

4.3

Mike Zender,
Zender +
Associates, Inc.

Media Working Group
poster/folder. 18″ x 16″.
Blended fountain (1.3)
combined with gold
metallic (1.8) solid cov-
erage maximizes the
impact of two-color
printing.

4.4

Clifford Stoltze
Design

AIGA Boston Dutch
lecture series poster,
17" x 21".
Day-Glo (1.8) halftone
combined with dark
purple match ink create
a dramatic and
elusive quality.

4.5

Siebert Design
Associates

Sound Images folder,
9" x 12".
Four metallic colors
(1.8) and die-cutting
(1.9) reversed out of
black (1.1) combine to
make a dramatic
presentation.

Adams Landing

4.6

Pricsilla Fisher,
Zender +
Associates, Inc.

Adams Landing
brochure, 12" x 12".
Varnish mixed with a
tint of silver (1.8) over-
prints the black bars,
making a delicate tex-
ture to contrast with the
stark black and crisp
four-match color
(3.1) symbol.

<<< Data-Mail has
consolidated the
most advanced
computer
personalization
technology and
traditional letter-
shop capabilities
to create a
full-service,
state-of-the-art
mail processing
facility.

Assuring success in today's highly competitive direct mail marketplace means choosing a direct mail processing company that is cost-effective and innovative; a company that sets the pace, not just follows it.

Data-Mail is that company.

A leader in the direct mail industry. Data-Mail has a proven reputation for excellence. Our company's extensive capabilities enable us to meet the demands and challenges of the most sophisticated mail marketer.

Focusing our attention on the current and future needs of our clients is our #1 goal. This is what motivates and drives Data-Mail to continue its pace-setting advancements in technology and quality control.

We have created a joint venture with a major European direct mail processing firm to provide a global direct mail resource for our clients.

Our facility encompasses more than 170,000 square feet on 15 acres—every project is completely processed without ever leaving our premises.

4.7

Michael Ostro,
Ostro Design

Data Mail brochure,
12" x 12".
Black mezzotint
halftones (1.2 screen
type) printed over two
solid metallic colors
(1.8) combines to create
a double duotone
(2.4) effect.

4.8

Siebert Design
Associates

CCM brochure 11" x
8.5".Die-cuts (1.9) com-
bined with various col-
ors of paper (1.4) and
two different ink colors
on each signature (2.1),
for a playful and color-
ful result.

What is C C M ?

What is C C M ?

What is C C M ?

What is C C M ?

What is C C M ?

Notice how the large purple reverse (1.1) on the pink cover paper (1.4) creates the impression of pink type on purple paper for great variety at little cost.

4.10

Tenazas Design

Transparency document, 6" x 9.5".
Translucent paper (1.9) combined with two ink colors (2.1 and 2.2) and a colored opaque paper (1.4) insert create a delicate and rich color variety appropriate to the topic.

T R A

T R
N S P
A R E
N T

The paper gallery is a manifestation of my current state of thinking. It personalize the resources around. Each element in the room, each grouping, reflects the inner workings of my brain. It records personal problems and struggles as I devote myself to embodied of non-thinking for example.

I am interested in evoking meanings through mental associations that are not immediate but are arrived at over time and are more profound than the initial reading, a verbal wordplay that is open to interpretation.

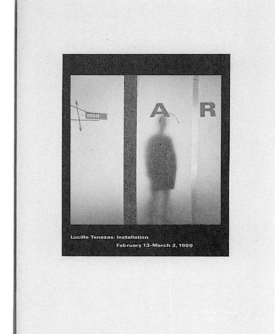

Lucille Tenazas: Installation
February 13–March 2, 1990

Over the past ten years, my work has possessed a transparency about it, a lyrical ordering of text and images that to me now seems like well-executed formal arrangements. I am no longer interested in formal layering but in a mental layering, not unlike some of the powerful suggestions of the Surrealist photographers, notably Man Ray, whose ambiguous images spoke on successive levels of meaning.

The upper gallery is a manifestation of my current state of thinking. It personifies the **present tense.** *Each element in the room, each gesture, reflects the inner workings of my brain. It records process, problems and struggles as I divest myself of one level of transparency for another.*

4.11

Tenazas Design

Notice how the soft focus on the photo relates and enhances the blurred type on the opposite side of the translucent sheet.

4.12

Crit Warren,
Schmeltz +
Warren

John Starnge folder
and stationery system.
A different, second
match color (2.1) in the
squares of each piece
(1.5) gives a delicate
color variety to
this system.

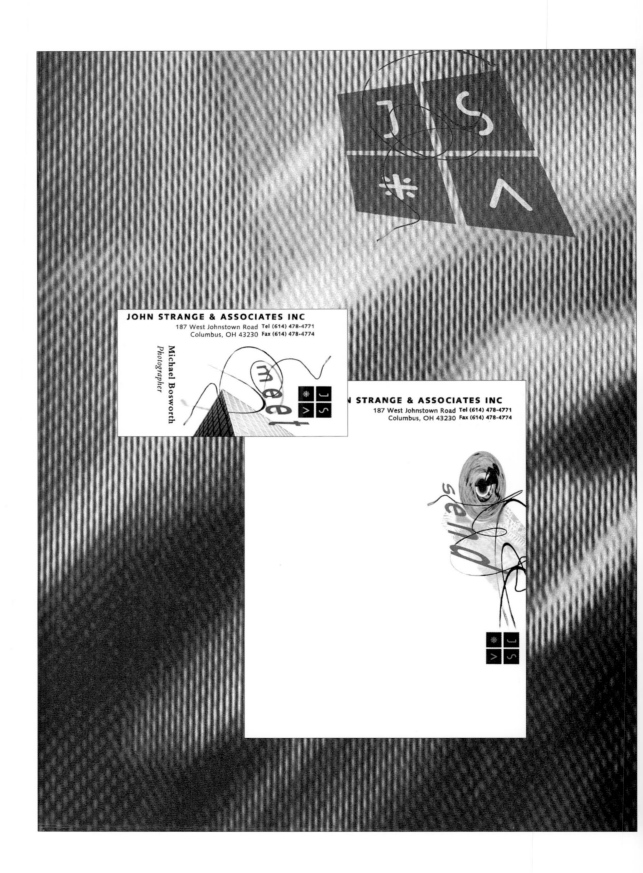

JOHN STRANGE & ASSOCIATES INC
187 West Johnstown Road **Tel (614) 478-4771**
Columbus, OH 43230 **Fax (614) 478-4774**

Michael Bosworth
Photographer

N STRANGE & ASSOCIATES INC
187 West Johnstown Road **Tel (614) 478-4771**
Columbus, OH 43230 **Fax (614) 478-4774**

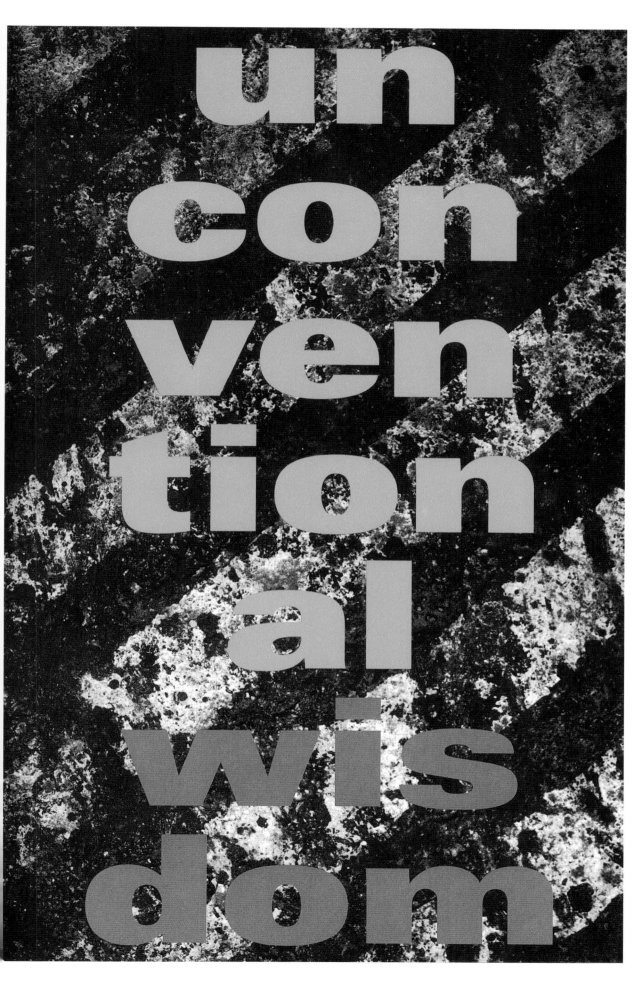

un
con
ven
tion
al
wis
dom

4.13

Michael Glass

Columbia College
brochure, 10" x 15.5".
Day-Glo and metallic
inks (1.8) combine with
a black halftone (1.2) to
create an unconven-
tional statement.

4.14

Nancy Skolos,
Skolos/Wedell,
Inc.

Stationery system. A
different second color
(1.5 and 2.1) on each
piece with a consistent
gray yields unity and
diversity for little
money. Notice the
effective use of the
smooth gradation (1.2)
to maximize the
value range.

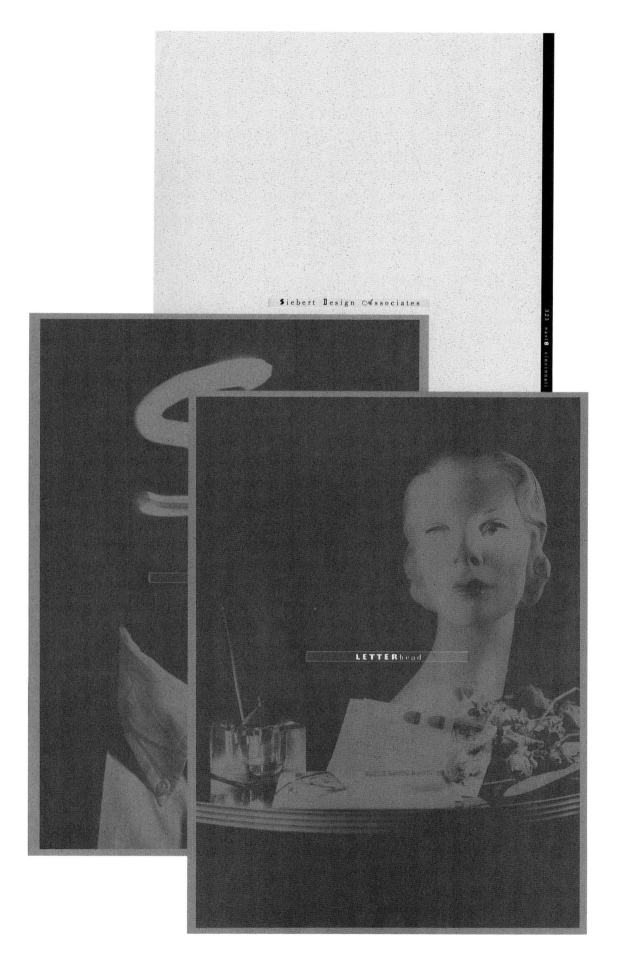

4.15

Siebert Design
Associates

Stationery system.
A different two-color
(2.1) combination on the
backs (1.6) of different
pieces (1.5) combines
with different colored
paper stocks (1.4) to
add richness
and variety.

4.16

Tenazas Design

Adopt a Book poster
and card. Tint of ochre
behind book photo
makes a duotone effect
(2.4), while tints of black
and ochre (1.2) add mul-
tiple readings to the
type. The whole is an
enriched and appropri-
ate message. Poster
and card were printed
at the same time (1.9)
for additional savings.

4.17

Tenazas Design

BROWSE LOOK CHOOSE OPT for BOOKS MUSIC REFRESHMENTS

Fourth Annual

A D O P T
d choose
— a—
L
B O O K
s

ARCHITECTURE
and
DESIGN Library

Monday Evening
April 20, 1992
5-9pm

CALIFORNIA COLLEGE OF ARTS AND CRAFTS
San Francisco Campus
1700 17th Street
at
DeHaro

4.17

Tenazas Design

4.18

Zender +
Associates, Inc.

Deloitte Touche
Tohmatsu International
brochure,
8.25" x 11.75".
A different pair of com-
plementary colors,
red/green and
yellow/purple, and their
tints (2.1 and 2.2), were
printed on opposite
sides (1.6) of the 16-
page signature. Notice
how the overprinting of
the complements (2.1)
results in black in the
square at the top of the
page. Also note the
duotones (2.4) made by
overprinting round dot
and bitmap halftones.

Pioneers were not
only great observers
and postulators, but
great reporters and
teachers as well. Their
feats would have been
virtually meaningless
had their communities
not been receptive to
change. The successful
transformation of any
organization must
address human issues
and demystify the
process of change,
every step of the way.

beyond seeking distinctive
pathways for software
applications. It defines
and then links information
requirements with the
operational needs unique
to your business. And
whether the solution
requires a simple tune-up
or deep, core change,
Deloitte Touche Tohmatsu
International's structured
approach of As-Is/To-Be
Modeling will identify and
quantify payback
opportunities wherever
they exist.

8|9

*T*he vision of an apparatus that would permit Man to soar across the heavens captivated history's most imaginative thinkers. Their elegant designs and detailed models grew into working prototypes and fearless experimentation. Whether building a rocket or reorganizing your business processes, controlled testing in "real-life" conditions is critical to achieving successful, predictable results.

PILOTING
means testing the model under real conditions.

The problem, as Orville and Wilbur Wright saw it, was not how to make a heavier-than-air machine fly, but how one might become a pilot. The Wright brothers were the first to realize that control was the key to sustained, powered flight. In addition to developing the first wind-tunnel to test airfoil, they devised trailing edge surfaces that could be adjusted in flight to achieve controlled take-offs, landings and turns.

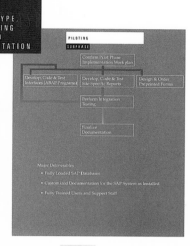

**PROTOTYPE,
PILOTING
AND
IMPLEMENTATION**

PROTOTYPE
SUBPHASE

- Confirm Prototype Workplan
- Develop Prototype Flows
- Determine SAP Configuration
- Set-Up SAP Dynpros & Tables
- Plan Data Conversion
- Customize SAP System
- Develop New Procedures
- Develop Conversion Programs
- Conduct Prototype Test

Major Deliverables
- Working Prototype

PILOTING
SUBPHASE

- Confirm Pilot Phase Implementation Workplan
- Develop, Code & Test Interfaces (ABAP Programs)
- Develop, Code & Test Site-Specific Reports
- Design & Order Pre-printed Forms
- Perform Integration Testing
- Finalize Documentation

Major Deliverables
- Fully Loaded SAP Databases
- Customized Documentation for the SAP System as Installed
- Fully Trained Users and Support Staff

IMPLEMENTATION
SUBPHASE

- Confirm Implementation Workplan
- Perform Data Conversion
- Cutover to Live Production
- Plan Ongoing Support
- Conduct Post-Implementation Review & Approve Deliverables

Major Deliverables
- Fully Implemented and Operational SAP Integrated Software System
- Fully Loaded Databases
- Determination of Ongoing Support Requirements
- Documentation for the SAP System as Installed
- Fully Trained Users and Support Staff

The development of a working prototype is as critical in testing SAP implementation models as it was in perfecting the airfoil of the Wright brothers. In this third Superphase, 4FRONT for *SAP Implementation* focuses on transforming the To-Be Model into a working reality supported by SAP applications. The Prototype, Piloting and Implementation Superphase covers these phases:

Prototype
Develops a comprehensive working system with SAP applications meeting actual needs and expectations. The prototype is executed using the on-line system and batch processes to simulate the proposed process redesign and systems set-up.

Piloting
Encompasses all activities required to transform the working prototype into a repeatable production of the SAP implementation. Throughout the piloting phase, detailed procedures for system-wide conversion are analyzed and documented to ensure future successful implementation at each site.

Implementation
Physically converts the old system to the new system in a controlled process. An implementation workplan specifies step-by-step data conversion and provides on-going technical support at each site.

These are the stages where we roll up our sleeves and the technical fun begins.

The key to successful piloting and implementation lies in the structured and well-documented approach that is the hallmark of Deloitte Touche Tohmatsu International. 4FRONT for *SAP Implementation* is a road map that lets us concentrate on meeting project specifications using time-tested workplans. Each task is documented, each accomplishment summarized, no step wasted and no problem overlooked. Ultimately, it is the methodology, experience and training of Deloitte Touche Tohmatsu International SAP specialists that move a project forward confidently to completion.

4.20

Clifford Stoltze
Design

The Art Institute of
Boston brochure,
11″ x 15″.
Metallic green (1.8)
combined with black
halftone (1.2) and match
lavender background
(3.1) creates an apt
image for art school.

reflect

thoughts for

1993

renew

revisit

rejoice

Stewart Monderer Design, Inc.

4.21

Stewart Monderer
Design

Card, 8.5" x 21".
Light two-color tints
(1.2) and reverses (1.1)
suggest changing
paper color.

4.22

Hornall Anderson
Design Works,
Inc.

Boldly into Tomorrow
invitation, 6.5" x 6.5".
Three-color foil stamp
(1.8) and die-cut (1.9) on
black paper create a
bold illustration.

BOLDLY

INTO TOMORROW

MARKETING

CONFERENCE 1992

FEBRUARY 16 - 18

SCOTTSDALE

CONFERENCE

RESORT

SCOTTSDALE, AZ

HEALTH ◼ WISE

**Rutland Regional Medical Center
Summer 1992**

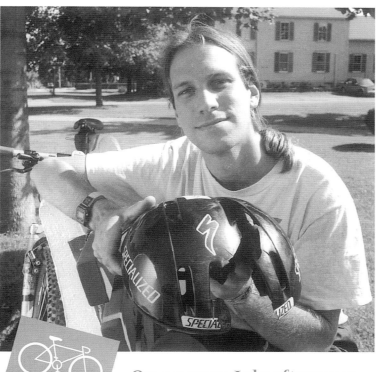

On a sunny July afternoon,

Christopher Smith of Rutland and two friends headed out on their bikes to the driving range to hit a few golf balls. For someone like Chris who is used to biking as far as 40 miles in one day, the excursion was nothing special. But this particular day would stand out in his memory.

"There was a hill," he says slowly, replaying the accident in his head. It all happened too fast for him to absorb every detail. "One of the few things I remember is that my girlfriend said 'Slow down. You're going too fast.'"

◀ *continued on back cover*

Fall HealthWise course listing inside ▶

4.22

Frank Armstrong,
Armstrong Design
Consultants

Healthworks newsletter, 7" x 11".
Two complementary
colors (2.1) combine to
make gray duotone
photos (2.4), making two
colors look like three.

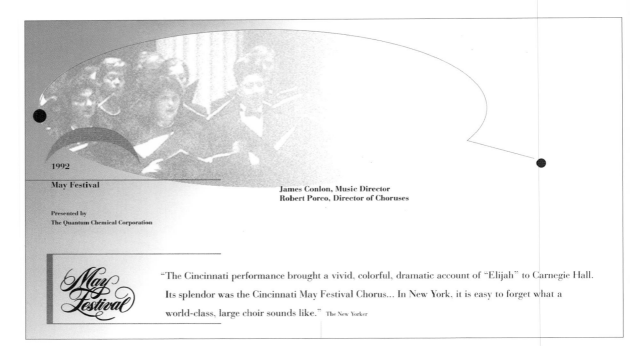

1992

May Festival

Presented by
The Quantum Chemical Corporation

James Conlon, Music Director
Robert Porco, Director of Choruses

May Festival

"The Cincinnati performance brought a vivid, colorful, dramatic account of "Elijah" to Carnegie Hall. Its splendor was the Cincinnati May Festival Chorus... In New York, it is easy to forget what a world-class, large choir sounds like." The New Yorker

4.24

Zender +
Associates, Inc.

May Festival brochure,
6" x 10.5".
Four match colors (3.1)
mix as they blend (1.2),
creating a maximum
number of hues. Notice
how round-dot and line
halftone screens com-
bine to overlap blends
without moiré.

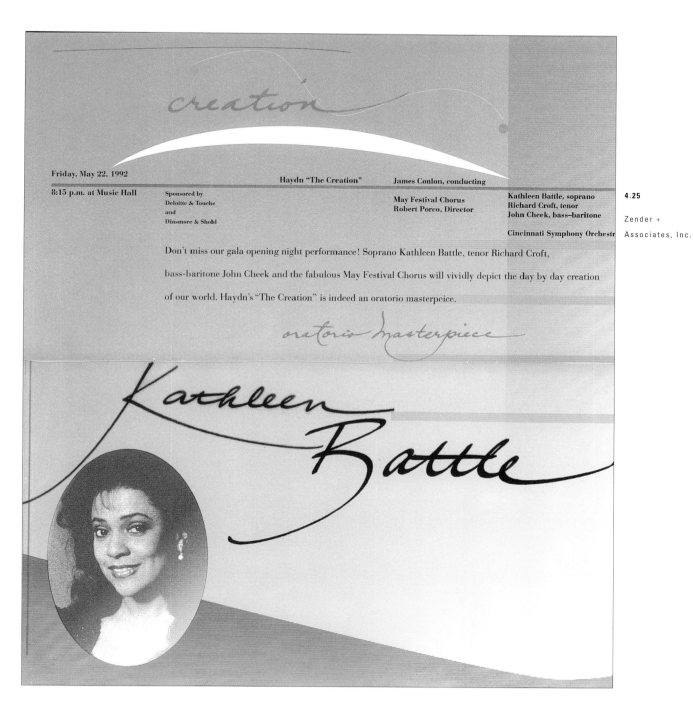

creation

Friday, May 22, 1992

8:15 p.m. at Music Hall

Haydn "The Creation"

James Conlon, conducting

Sponsored by
Deloitte & Touche
and
Dinsmore & Shohl

May Festival Chorus
Robert Porco, Director

Kathleen Battle, soprano
Richard Croft, tenor
John Cheek, bass–baritone

Cincinnati Symphony Orchestra

Don't miss our gala opening night performance! Soprano Kathleen Battle, tenor Richard Croft,

bass-baritone John Cheek and the fabulous May Festival Chorus will vividly depict the day by day creation

of our world. Haydn's "The Creation" is indeed an oratorio masterpeice.

oratorio masterpiece

Kathleen Battle

IMAGE

Peg Faimon

Image + Text poster,
11″ x 17″.
Three color tints (3.1)
and reverse (1.1) areas
combine in a delicate
color balance.

Department of Art Faculty Exhibition

Miami University:

IMAGE + TEXT

Fourth Street Gallery
314 West Fourth Street
Cincinnati, Ohio 45202
513 621 0069

MAY 7 – JUNE 20, 1993

Closing Reception
June 18, 1993, 6–9 PM

Lon Beck
Crossan Curry
Denny Fagan
Peg Faimon
Suzanne Fisher
Miriam Karp
Eunshin Khang
Sandy Lopez-Isnardi
Ed Montgomery
Ellen Price
Linda Sheppard
Ron Stevens
Bob Wolfe

+ TEXT

PRINT CRAFT ST. PA. , MN.
Quality Pr g Samples
CRAFT
ORATED
ORATED
PRINTER
GOOD AS OUR PRICES
PH. 612
633 812

The Proof is in the Printing
Telephone 633-8122
CALL TODAY FOR A QUOTE

PRINT CRAFT INCORPORATED
315 5TH AVE. N.W. ST. PAUL, MINNESOTA 55112
PRODUCT OF THE U.S. OF A.

4.27

C.S. Anderson
Design Company

Print Craft sample package, 11.5" x 9".
Two ink colors (2.1) on varicolored paper stock (1.4), combined with a brown sticker (1.4 and 1.9) give this the appearance of a four-color job.

Index of Contributors

C.S. Anderson Design Co.
30 N. First St.
Minneapolis MN 55401

Frank Patton Armstrong
PO Box 88
Groton MA 01450-0088

Daniel V. Bittman
Design Team One, Inc.
49 E. Fourth St., 10th Floor
Cincinnati OH 45202

Joe Bottoni
1235 Halpin Ave.
Cincinnati OH 45206

Christine Celano
2527 W. Moffat, Unit C
Chicago IL 60647

Karen Cramer
Hornall Anderson Design Works
1008 Western Ave., 6th Floor
Seattle WA 98104

Robert Davison
Stewart Monderer Design, Inc.
10 Thatcher St., Suite 112
Boston MA 02113

Peg Faimon
Miami University
Rowan Hall/Art Center
Oxford OH 45056

Michael Glass Design
213 W. Institute Pl, Suite 608
Chicago IL 60610

KODE
20 W. 20th St., Suite 308
New York NY 10011

M Plus M Incorporated
17 Cornelia St.
New York NY 10014

Ostro Design
147 Fern St.
Hartford CT 06105

Roger Sametz
Sametz Blackstone Assoc.
40 W. Newton St.
Boston MA 02118

Gary Sankey
Wexner Center for the Arts
N. High St. at 15th Ave.
Columbus OH 43210

Douglass Scott
WGBH
125 Western Ave.
Boston MA 02134

Lori Siebert
Siebert Design Assoc., Inc.
323 E. Eighth
Cincinnati OH 45202

Nancy Skolos
SKOLOS/WEDELL, INC.
529 Main St.
Charlestown MA 02129

Clifford Stoltze
Clifford Stoltze Design
49 Melcher St.
Boston MA 02210

Terry Swack
Terry Swack Design Assoc.
49 Melcher St., 4th Floor
Boston MA 02210-1551

Lucille Tenazas
Tenazas Design
605 Third St., Suite 208
San Francisco CA 94407

Douglas Wadden
University of Washington
School of Art/Graphic Design
Seattle WA 98195

Crit Warren
Schmeltz and Warren
74 Sheffield Rd.
Columbus OH 43214

Melissa Waters
Liska and Associates, Inc.
676 St. Clair, Suite 1550
Chicago IL 60611-2922

Zender + Associates
2311 Park Avenue
Cincinnati, OH 45206

Index